IMAGES
of America

BELLPORT VILLAGE
AND
BROOKHAVEN HAMLET

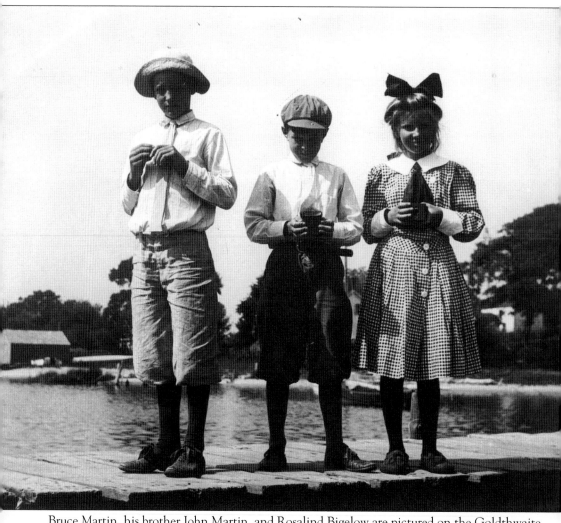

Bruce Martin, his brother John Martin, and Rosalind Bigelow are pictured on the Goldthwaite Inn dock c. 1910. The small building on the left is the Overton sawmill, which stood on the east side of the Overton Slip, just east of the foot of Bellport Lane. (Courtesy Bellport-Brookhaven Historical Society.)

To my brother Eugene Jr.
and to
JPR.

IMAGES
of America

BELLPORT VILLAGE
AND
BROOKHAVEN HAMLET

Victor Principe

ARCADIA

Copyright © 2002 by Bellport-Brookhaven Historical Society.
ISBN 0-7385-0968-X

First printed in 2002.

Published by Arcadia Publishing,
an imprint of Tempus Publishing, Inc.
2A Cumberland Street
Charleston, SC 29401

Printed in Great Britain.

Library of Congress Catalog Card Number: 2001096128

For all general information contact Arcadia Publishing at:
Telephone 843-853-2070
Fax 843-853-0044
E-Mail sales@arcadiapublishing.com

For customer service and orders:
Toll-Free 1-888-313-2665

Visit us on the internet at http://www.arcadiapublishing.com

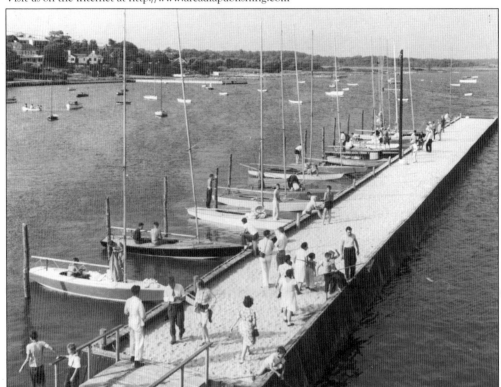

This photograph was taken during the Atlantic Coast Championship for the International Star Class racing sloop in 1947. The Great South Bay was one of the most active racing centers for this boat, and Bellporters who sailed it were among the best. (Courtesy Bellport-Brookhaven Historical Society.)

CONTENTS

ACKNOWLEDGMENTS

This book would not have been possible without the cooperation and full support of the Bellport-Brookhaven Historical Society. I am especially grateful to Dr. Carol Bleser for her enthusiastic encouragement and historical advice and to Robert Duckworth for his much appreciated help with the contemporary photographs. I am indebted to village historian Emily Czaja, who generously shared her knowledge with me. I also want to thank Norman Nelson and Florence Pope of the Post-Morrow Foundation. I am grateful to Ellen Williams for her assistance with the Brookhaven Hamlet sections. I want to express my appreciation to those who shared their reminiscences or pictures with me, including Ruth Allen, Elizabeth Atwood, Richard Baldwin, Dr. Richard Berman, Prisilla Carleton, Kathy Ellis, John Everitt, Rev. William Fields, Concetta Grucci, Gardiner Hulse, Nancy Ljungquist, Nancy Meade, David Meitus, Natalie Paige, Betty Puleston, Mayor Frank Trotta, Robert Wallen, and Barbara Weiser. I also thank Patricia Campbell and Nan Bunce of the South Country Library and Elizabeth Burns of the Brookhaven Free Library. In addition, I want to acknowledge the help of Tom Binnington, Arlene Capobianco, Gerard Comier of the Marist Brothers, Madge Green, Jeb Lee, and Geoffrey Weber. Five people—Dr. Carol Bleser, Emily Czaja, Dr. Ira Hayes, Dr. John Renninger, and Ellen Williams—invested much time in reading the entire manuscript, and this study benefited from their graceful recommendations. Finally, I thank John Renninger for his companionship and constant support.

—Victor Principe
Bellport, New York

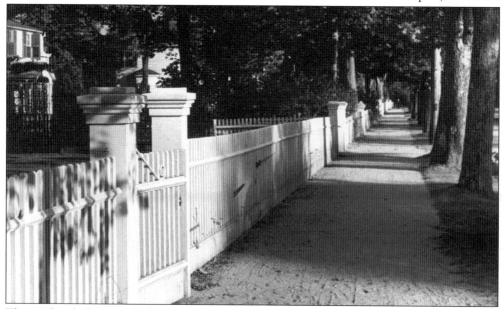

This undated photograph depicts the quintessential Bellport: large leafy trees, white picket fences, graceful Bellport gates, and old houses with green wooden shutters. (Courtesy Bellport-Brookhaven Historical Society.)

INTRODUCTION

Thomas and John Bell did not have a summer resort in mind when they started their village. They envisioned a commercial seaport, but such a port was not what developed. The natural attractiveness of the Bellport highland and the Brookhaven lowland, coupled with the closing of an inlet to the sea, made the area prime for recreation, not commerce. This volume shows in pictures the Bellport and Brookhaven Hamlet area that developed after the Bells.

The land on which Bellport Village and Brookhaven Hamlet are situated was purchased from the Unkechogue Indians on June 10, 1664, by men who had previously settled Setauket. On eastern Long Island in the 17th century, land was not merely acquired free of all claims. It was bought, and definite procedures had to be followed. England recognized the Native Americans as the rightful owners of Long Island. The settlers from Setauket, therefore, had rules to follow when transacting business with the chief of the tribe, Tobaccus.

The settlers purchased sections of land defined by streams: Little Neck, Fire Place Neck, Tarmen's Neck, Dayton's Neck, Occumbomuck Neck, and Starr's Neck. They called the area Old Purchase at South, and these necks of land today define Bellport, Brookhaven Hamlet, and the western part of South Haven. Soon after acquisition, this land was divided among the original purchasers into 49 "meadow shares," valuable because of the salt hay, or kelp, that bordered the bay. In addition to salt hay, the offshore whaling industry was an attraction.

The Native Americans taught the settlers how to hunt whales and extract whale oil. Thanks to the inlet that lay southwesterly on the barrier beach, the ocean was accessible. Opposite the inlet across the bay was the mouth of the Connecticut (Carmans) River, which provided access into the interior of the settlement. It is assumed that Brookhaven Hamlet was originally called Fire Place because of the fires that were lit on the riverbanks to guide ships on the ocean through the inlet and toward the river landings.

In this period, the settlers did not move here permanently; they continued living in the 1655 settlement of Setauket. Bellport and Brookhaven were strictly investment property. In 1676, they voted to add 15 acres of upland to each of the 49 meadow shares, and this extra acreage was known as the "15-acre lots." By 1681, Jonathan Rose, Richard Floyd, and Richard Starr began acquiring the lots and adjoining meadow shares. Thomas Rose became the first permanent resident of the settlement known as Fire Place (later known as Brookhaven Hamlet), and his brother Jonathan became the first permanent resident of Occumbomuck (later known as Bellport). By 1720, the Rose family was the principal owner of the land comprising Bellport. In 1735, the names of Hulse, Hawkins, Helm, Bayles, Wood, and Tuthill are seen as other owners of the meadow shares. After a number of years, the Roses in Occumbomuck sold their property. By the time of the Revolutionary War, Justice Nathaniel Brewster was the principal owner of Bellport, with the other leading names being Samuel Conklin, Thomas Fanning, and Zophar Hawkins. In the late 1820s, the heirs of Nathaniel Brewster's son sold their share of the Brewster holdings to Charles Osborn, Solomon Livingston, Polly and Matthew Woodruff, and Henry Hulse.

Capt. Thomas Bell came to Occumbomuck on assignment from his employers. He was an employee of the American Coast Wrecking Company and was sent here to wreck a ship that had foundered off the coast. He liked the area so much that he decided to settle here. In 1829, he and his brother purchased from Matthew Edmund Woodruff and Henry Hulse Jr. the land that today forms the heart of the village south of South Country Road. The brothers and Col. William Howell then built a dock and a road to the dock (Bell's Dock and Dock Road).

They soon subdivided the land along the road (selling the parcels at very reasonable prices), and the village grew quickly. The Bells built a shipyard. The future they envisioned for Bellport was that of a bustling commercial seaport. This was not to happen because the Old Inlet, which provided Bellport with convenient access to the ocean, was soon closed. Commercial shipbuilding continued but gradually faded. Ironically, Bellport was to become a place of recreation and pleasure rather than of commerce.

Nonetheless, the communities of Occumbomuck and Fire Place prospered with shipbuilding, farming, whaling, fishing, shellfish harvesting, hunting, and the shipment of cordwood and salt hay. Captain Bell named his village Bellville. He opened up Academy Lane and connected it to Dock Road and to old Browns Lane (which already existed) with Front Street near the shore. When application was made for a post office and denied because there was another Bellville in New York State, the name Bell Port was adopted. After 1861, Bell Port became one word. In 1871, the residents of Fire Place changed the name of their settlement to Brookhaven Hamlet, perhaps with the notion of erasing the Native American origins of the original name.

By the mid-19th century, Bellport was fast becoming a summer resort as visitors from the city discovered its natural attractions. They were attracted to Bellport because it was a reasonable distance from the city and had so much to offer: sailing, swimming, and tennis in the summer and hunting (especially fowl hunting) and scootering in the winter. Existing boardinghouses were enlarged and, by the 1870s, hotel construction was in full swing. In the early 20th century, there was a building boom of summer cottages. Brookhaven Hamlet, meanwhile, maintained its quiet rural character yet later had some boardinghouses of its own. Bellport and Brookhaven Hamlet both attracted prominent people in the social, business, and artistic world. They could take a train to Tooker's Turnout (the original Bellport station, north of Bellport on the Greenport line of the Long Island Railroad) and connect by stagecoach to Bellport via Railroad Avenue, which was laid out by 1851. By 1881, the Montauk line was opened farther south.

Things slowed down considerably by the 1930s. Most hotels were unable to attract their previous clientele. The luxurious Bay House, which catered to a very wealthy class of guests, had become a summer camp c. 1900. By the early 1950s, it was gone. The other hotels were torn down in the late 1930s or early 1940s, except for the Wyandotte, which lasted until the late 1950s. After World War II, nearby Camp Upton (which was used to train army recruits for both world wars) was recycled as Brookhaven National Laboratory. Although Bellport had retained summer residents through this period, the "lab people" infused Bellport and Brookhaven Hamlet with new energy. Unfortunately, the 1950s saw the destruction of several old houses on the north side of South Country Road in Bellport, including the Captain Edward Osborn House, the Titus House, and the Bieselin House. These properties were then subdivided and the intact westerly tracts progressively suburbanized.

Fortunately, however, both Bellport and Brookhaven Hamlet managed to retain their charm. A summer colony persisted. The famous continued to come. Perhaps because Bellport and the hamlet are relatively isolated and not on the Montauk Highway is the reason they escaped the worst aspects of suburbanization. Another reason must lie with the citizens, who have loved and cared for their communities.

One

THE OLD HOTELS
OF BELLPORT

*Bellport has been declared by an English Lord to be
the prettiest and nicest place in all the world. . . . Bellport yields
the palm to none as a resort for spring, summer and autumn.*

—George T. Sweeny
From *Long Island: The Sunrise Homeland* (1926)

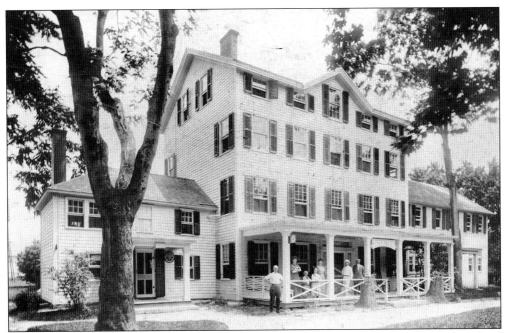

Capt. Thomas Bell and his brother Capt. John Bell built a double house on the eastern side of Bellport Lane, where the village parking lot is now, so that their families could be together while the two men were off at sea. In 1833, the Bell House provided boarding for Bellport Classical Institute students who lived out of town. Later, the house was enlarged when the Bells began providing accommodations for summer visitors. The Bell House became known as the Mallard Inn *c.* 1900. It was purchased by the Raymond family in 1911 (when this photograph was taken) and was renamed the Bell Inn. It was torn down in the early 1930s. (Courtesy Bellport-Brookhaven Historical Society.)

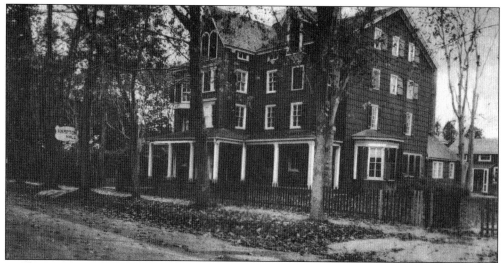

The Titus House, later known as Hampton Hall, stood on the north side of South Country Road west of the village center opposite the Otis estate. It was built in the early 19th century as a private home by Hampton Howell. In 1860, Henry Weeks enlarged it to a boardinghouse for 50 guests. An addition (a small building known as Ladies Hall, which originally stood on the southeast corner of Academy Lane and South Country Road) was attached to the north side of the building. Its second floor contained a theater. (Courtesy Bellport-Brookhaven Historical Society.)

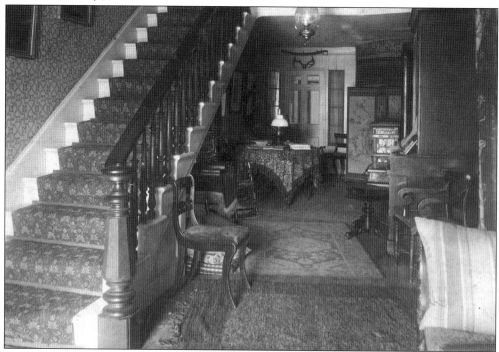

This rare photograph of the entrance hall and stairwell at the Titus House dates from 1900. A pipe organ belonging to Henry Weeks Titus and his daughter Susan can be seen on the right. The glazed door in the rear led to a dining room, which was the first floor of the addition. (Courtesy Bellport-Brookhaven Historical Society.)

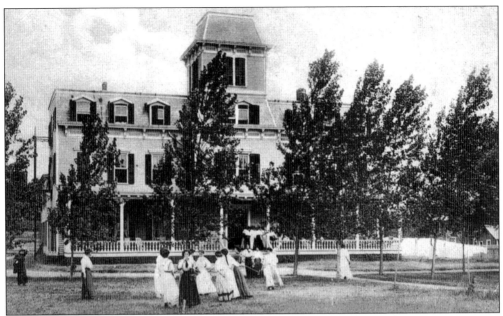

The Bay House was built as a luxury hotel in 1874 and stood on the west side of Bellport Lane at the bay, about where the band shell now stands. The foundation of the hotel's porch was incorporated into the base of the present bandstand. The hotel was sold *c.* 1900 to the Jewish Working Girls Vacation Society of New York, which used it for many years. In 1946, it became a summer camp for boys at the Admiral John Paul Jones Naval Academy. In 1950, it was purchased by the village. The building was removed, and the land was developed as a park. (Courtesy Bellport-Brookhaven Historical Society.)

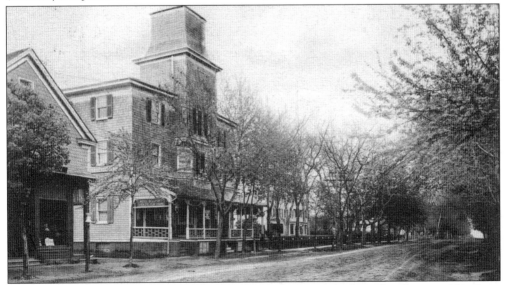

The Bellport Hotel, built in 1898 on Bellport Lane, is now a shadow of its former self without its proud center tower and wooden shingles. No longer a hotel, the building houses the Chowder House Restaurant at its base and apartments above. The Bellport Hotel was the last hotel built in Bellport and is the only surviving relic of that era. South of the hotel, to the right, we glimpse the Bell House. (Courtesy Bellport-Brookhaven Historical Society.)

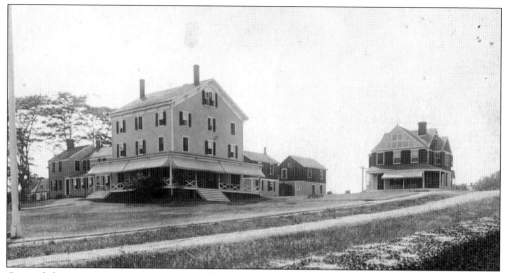

One of the most important hotels in Bellport was the Goldthwaite Inn, later known as the Grasspatch Hotel. It was located on Browns Lane, nearly opposite from where the Unitarian Universalist Fellowship is now. It started as a sort of bed-and-breakfast in the 1880s when Mr. and Mrs. Charles Goldthwaite started taking in guests at their nearby home, which they called the Teabox. They then leased a building on Browns Lane, added several cottages to its grounds, and called it the Goldthwaite Inn. The hotel's grounds extended to the bay. (Courtesy Bellport-Brookhaven Historical Society.)

The largest and most famous of the hotels in Bellport was the Wyandotte Hotel. It was located north and east of the Goldthwaite, the property entrance fronting Browns Lane, somewhat north of where Raynor Lane is today. The property was in the shape of an upside-down and reversed L, with its easterly depth to about where Brewster Lane is and angling about 90 degrees southerly to the bay. When William Kreamer ran the hotel, he inaugurated the hotel's famous Sunday duck dinner tradition. (Courtesy Bellport-Brookhaven Historical Society.)

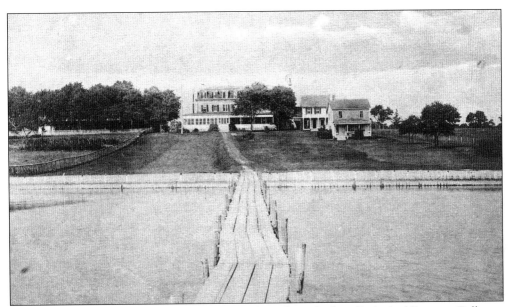

This 1908 postcard shows a view of the Wyandotte from the hotel's dock. (Courtesy Bellport-Brookhaven Historical Society.)

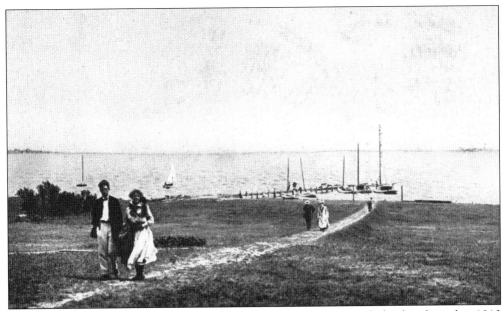

Guests of the Wyandotte are seen strolling from the dock toward the hotel in this 1910 postcard. (Courtesy Bellport-Brookhaven Historical Society.)

The Bellport Bachelors

cordially invite you to the second of a series of

Summer Dances

to be held at the

Wyandotte Hotel, Bellport, Long Island

Friday Evening, August fifteenth from ten until two

Music by Lem Johnson and his orchestra

Co - Chairmen

Eugene V. Connett W. Dorsey Smith

Two dollars per person - tax included

Reservations at Nancy Tibbs Gift Shop

In the late 1940s, Bud Connett and Dorsey Smith (calling themselves the Bellport Bachelors) organized a few summer parties at the Wyandotte. In addition to Lem Johnson, the Lester Lannin Orchestra made an appearance. (Courtesy Natalie Paige.)

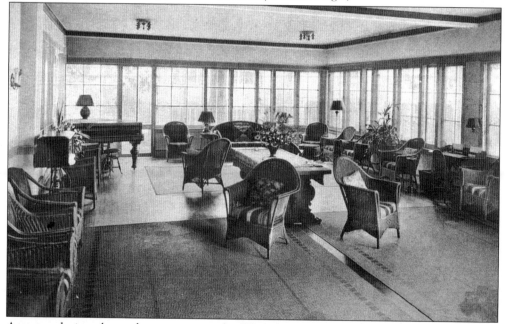

A postcard view shows the sunroom at the Wyandotte c. the 1920s. (Courtesy Dr. Richard Berman.)

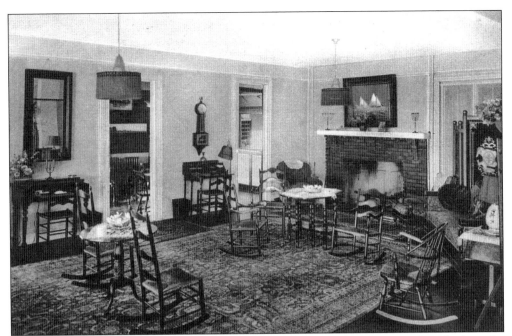

The Wyandotte lounge is shown in this c. 1920s view. The lounge was furnished in the Colonial Revival style, which was popular in America during this period. (Courtesy Dr. Richard Berman.)

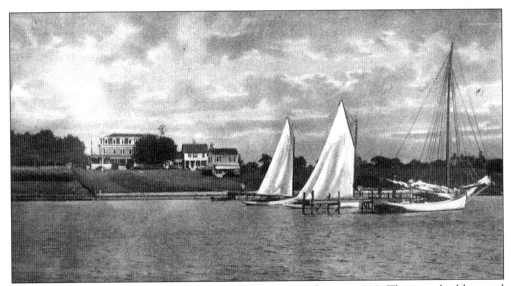

In this view, sailboats are moored at the dock of the Wyandotte c. 1918. The main building and cottages can be seen. Above the tree on the right side of the main building is a windmill. The Bellport and Brookhaven Hamlet sky was dotted with windmills at this time. Most of them were plain, utilitarian structures that supplied water by pumping. (Courtesy Bellport-Brookhaven Historical Society.)

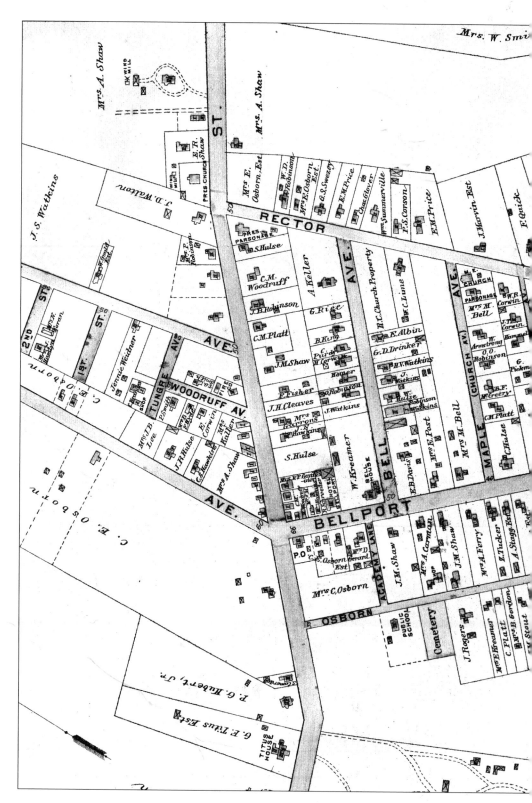

Mrs. W. Smi

Mrs. A. Shaw

EX WIND MILL

J. S. Watkins

J. D. Walton

ST.

Mrs. A. Shaw

E. R. Shaw
PRES. CHURCH

Mrs. E. Osborn Est.
W. D. Robinson
Mrs. E. Osborn Est.
G. S. Swezey
E. M. Price
Chas. Glover
Wm. Summerville
P. S. Corson
E. M. Price

J. Marvin Est.

F. Quick

RECTOR

PRES. PARSONAGE

S. Hulse

AVE.

J. Osborn

2ND ST.

Jennie Weidner

1ST ST.

WOODRUFF AV.

TUNGRE AVE.

C. M. Woodruff

A. Keller

J. B. Robinson

G. Rice

C. M. Platt

B. King

H. C. Church Property

W. C. Lane

M. E. CHURCH

AVE.

CHURCH

W. R. Corwin
PARSONAGE
Mrs. M. Bell
J. T. Corwin
W. Armstrong
O. O. Robinson
G. Picken

J. M. Shaw

Pratt
H. Corwin

F. Albin

G. D. Drinker

H. V. Watkins

J. Watkins

(CHURCH) AVE.

B. F. McCreery

C. M. Platt

F. Fisher

Homer

S. Robinson

J. Watkins

Robinson
Watkins

MAPLE

C. Hulse

J. H. Cleaves

J. Watkins

Mrs. C. Barrons
W. Dawkins

S. Hulse

W. Kreamer

B. Hulse

BELL

Mrs. E. Post

Mrs. M. Bell

Mrs. J. B. Lee

J. R. Hulse

E. Corwin

Mrs. Keller

Mrs. A. Shaw

C. E. Hawkins

AVE.

HOTEL POST

E. B. Davis

BELLPORT

P. O.

C. E. Osborn Est.

Gerard

J. M. Shaw

Mrs. A. Carman

Mrs. D.

J. M. Shaw

Mrs. A. Ferry

Z. Tucker

A. Stagg Est.

C. E. Osborn

ACADEMY LANE

OSBORN

PUBLIC SCHOOL

Cemetery

J. Rogers

Mrs. E. Kreamer

C. Platt

Mrs. B. Gordon

M. Stout

P. G. Hubert, Jr.

G. F. Titus Est.

TITUS HOUSE

16

This map shows Bellport c. 1900. Osborn Avenue is now Academy Lane, Bellport Avenue is Bellport Lane, Railroad Avenue is Station Road, and Rector Avenue is Browns Lane. From the bay north, Front Street is now Shore Road, Day Avenue is Pearl Street, Rider Avenue is Hulse Street, Maple Avenue is Maple Street, and Bell Avenue is Bell Street. The large estates are still intact. The Peat Hole (not seen) is the lake. All the hotels can be seen, as can the old golf course, lumberyard, and mill. The Methodist church is on Rector and Maple. The Presbyterian church is in its original building on Main Street, or South Country Road, opposite Rector. The Catholics own property but as yet have no church. The academy is in its original location above the old cemetery and opposite perpendicular Academy Lane, now Osborn Street. Not seen is South Howell's Point Road, then known as Maple Avenue. (Courtesy Bellport-Brookhaven Historical Society.)

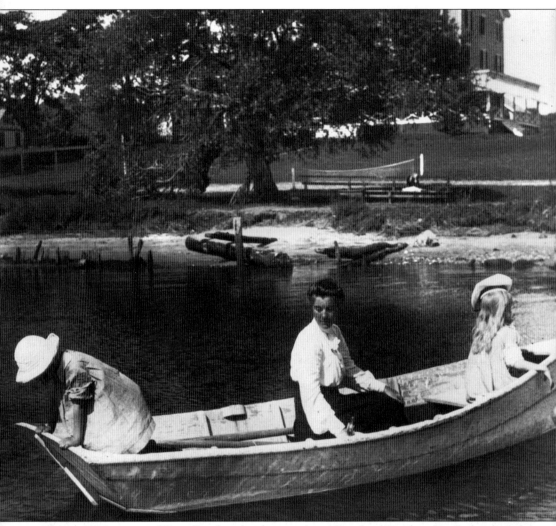

This *c.* 1905 picture of Perry Bigelow (at the stern) and Rosaland Bigelow (at the bow) evokes a different world. They are just east of Rowboat Beach, the area south of Front Street and east of Overton's Slip where many rowboats were pulled onto the shore. There is no bulkhead along the shore. The old willow tree behind them is partially hiding the Goldthwaite Inn. A bench used by local baymen (known as captains) while waiting for customers is under the tree, and the Goldthwaite's tennis court is behind it. Besides regular ferry service that began *c.* 1914, tourists could often find catboats owned by baymen along the shore between Bellport Lane and Browns Lane. The Goldthwaite's bench was one of the places where visitors could hire a captain to ferry them to points on Fire Island or just for a sail around the bay. The path along the shore, Front Street, is now Shore Road. (Courtesy Bellport-Brookhaven Historical Society.)

Two
THE BELLPORT SCENE

Above my head tall pines, pines older than I know,
Are sighing, bending, singing as they sway,
Whipped by a boisterous wind, and down below
I catch a glimpse of whitecaps on the bay.

—Birdsall Otis Edey
From "Where I Belong" (1931)

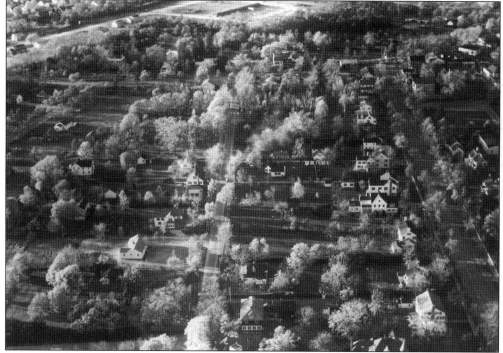

An aerial view of Bellport was taken in 1954 over one of the last streets to be laid out by Captain Bell, Academy Lane, found slightly left of center. The academy itself, having been moved twice, is sitting on its current site on the lower left. The Captain Edward Osborn House can be seen on South Country Road to the right of the intersection with Academy Lane on the upper right of center, its gazebo moved now to the yet-to-be subdivided property of 24 Bellport Lane below. Later, this gazebo was moved again and reconstructed on the grounds of the Bellport-Brookhaven Historical Society. To the extreme left we see a section of Livingston Lane lined with young sycamores. (Courtesy Bellport-Brookhaven Historical Society.)

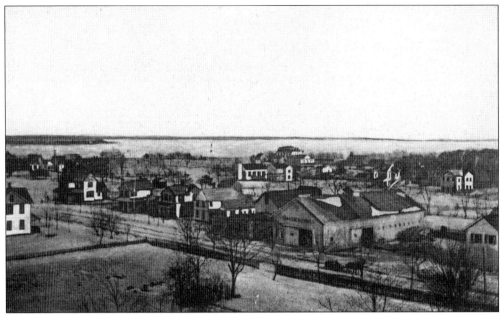

This late-19th-century postcard of Bellport shows the view looking east over Bell Street from the fourth floor of the Bell House. The large building, the Davis Livery, still stands, as do the homes near it. In the center of the picture, one can see the original Methodist church, which stood on Rector Street (Browns Lane) and Church Street (Maple Street). Beyond the church and to the right, the Wyandotte Hotel is visible. (Courtesy Bellport-Brookhaven Historical Society.)

The land east of Browns Lane is shown in this bucolic photograph, taken from the water tower at the Wyandotte Hotel in the 1890s. On the upper left, the Presbyterian church (now Methodist) can be seen. (Courtesy Bellport-Brookhaven Historical Society.)

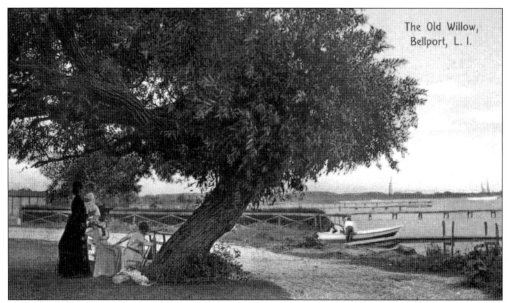

The old willow tree was a Bellport landmark in the early 20th century. It sat on the shorefront of the Goldthwaite Inn, and captains would wait there for customers to ferry to the beach. "Captain" was largely an honorific title: anyone who owned a boat was called a captain. The path in the foreground is Front Street (now Shore Road) c. 1908. The road turned left and north to become Rector Street (Browns Lane). The willow tree was just east of Rowboat Beach, a subject often painted by artist Walter Granville Smith in the early 20th century. (Courtesy Bellport-Brookhaven Historical Society.)

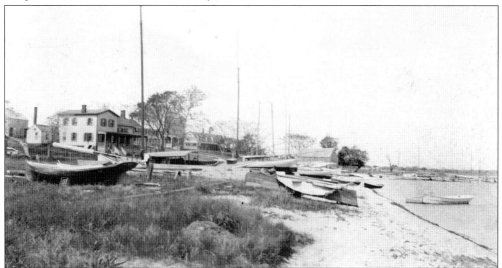

This view is east of the Overton Slip, which was at the foot of Bellport Lane, and shows Rowboat Beach in 1897. Front Street is barely discernible. In the distance (center left) is the home that was once owned by Charles Bedford of Standard Oil. To the left of it, behind the trees, is the main building of the Goldthwaite Inn. The old willow tree is in front of the hotel and to the right of a small boathouse. The Overton Slip—which had a mill, lumberyard, and coal depository on property owned by the Osborn family—was removed in the early 1920s. The land was made into Osborn Park. (Courtesy Bellport-Brookhaven Historical Society.)

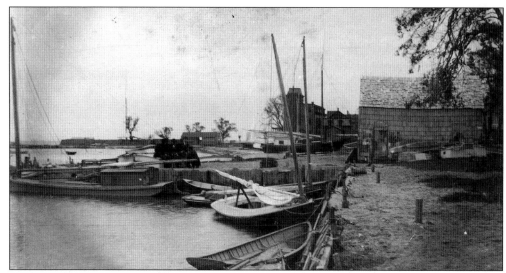

This picture shows a view of the Osborn property in 1897, when it was the Overton Slip. The mill building is to the right. The Bay House looms in the distance. Will Overton also had a boatyard just to the west of the Bay House next to the bathing beach. (Courtesy Bellport-Brookhaven Historical Society.)

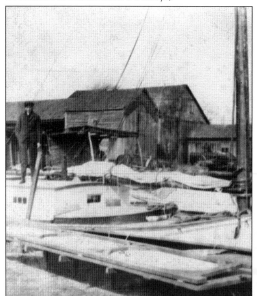

Left: The slip, yard, and mill buildings are pictured *c.* 1890. West of the slip stood the Overton Coal Yard and Office (not seen in this image). The person standing on the boat is George Pierman. (Courtesy Bellport-Brookhaven Historical Society.) *Right:* Paul Bigelow is about to board the *Quinnepiac* in Overton's Slip *c.* 1905. Later, Bigelow became a highly respected commodore of the Bellport Bay Yacht Club and, for many years, was on every race committee. Before the start of a race, he would hold up a feather to test the direction of the wind. The little building behind the sail is Overton's store and office, which stood on the corner of Shore Road and Bellport Lane. The store sold tobacco, candy, and soft drinks. The slip was a channel dug out in the center of the Osborn property. It was filled in when the buildings were removed and the land made into a park. (Courtesy Bellport-Brookhaven Historical Society.)

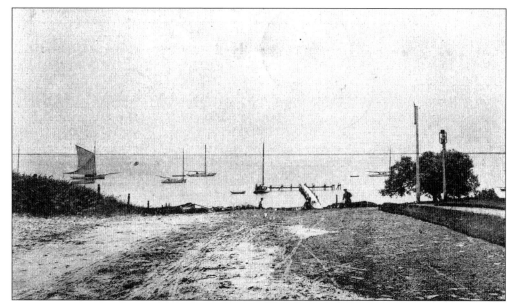

Looking south from the crest of the hill on Browns Lane, this *c.* 1912 view shows the old willow tree and the dock of the Goldthwaite Inn. Although most of the houses on the street today date from the last quarter of the 19th century, Browns Lane actually predates Bellport, having been used by fishermen and baymen from very early times. It may have originally been a Native American trail to the water. (Courtesy Bellport-Brookhaven Historical Society.)

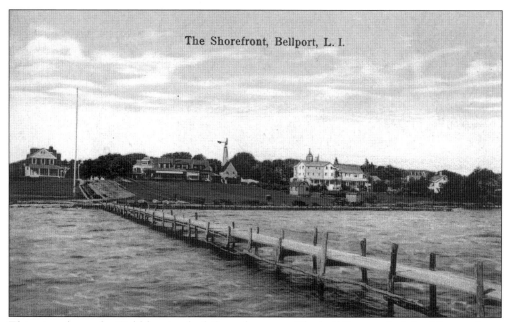

The Shorefront, Bellport, L. I.

This view shows the Goldthwaite dock from the water. The building on the left of Browns Lane is one of the hotel's cottages. On the right is Charles E. Bedford's home, which is now the Unitarian Universalist Fellowship. Peeking behind it to the left is the Teabox, a boardinghouse. The large white building to the right is Dr. Ralph Brandreth's home, which later became an annex to the Goldthwaite. (Courtesy Bellport-Brookhaven Historical Society.)

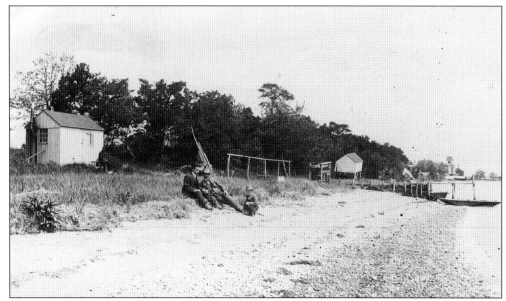

Rising in the background of this *c.* 1900 view is Osborn's Bluff. The picture shows the shore between Academy Lane and the Peat Hole. The house on the left belonged to Oliver Hawkins. It was common for single men to put up small houses such as this almost wherever they wanted. In the distance, the Bay House can be seen. (Courtesy Bellport-Brookhaven Historical Society.)

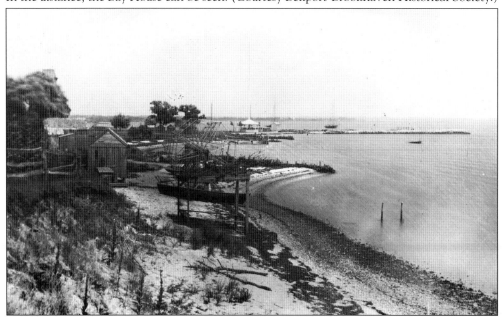

Another *c.* 1900 view of the shore, taken closer to the Bellport dock, looks east from the foot of Academy Lane. This was a bathing beach. Note the bathhouses built by Robinson and Watkins on the left. The circular apparatus in the center of the photograph was used to dry fishing nets. Capt. Ike Smith, Eva Smith's father, used it often. The summerhouse of the Bay House is to the right beyond; the top of the Bay House can be seen to the left behind the trees. The yacht club shared the same building with the golf club on the bluff from where this picture was taken. (Courtesy Bellport-Brookhaven Historical Society.)

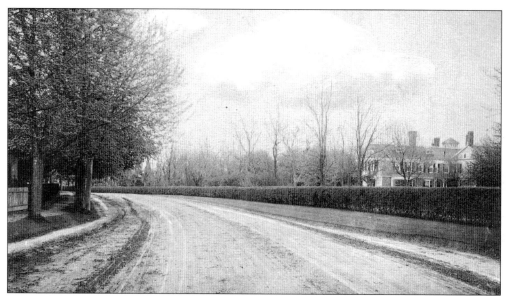

An unpaved South Country Road is seen in a view looking east *c.* 1910. The mansion on the right was the Otis property known as the Locusts, which became the clubhouse of the new golf club after 1917 and, later, that of the country club. (Courtesy Bellport-Brookhaven Historical Society.)

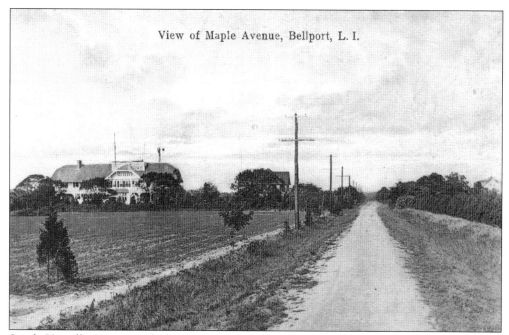

View of Maple Avenue, Bellport, L. I.

South Howell's Point Road, then known as Maple Avenue, appears in a view looking north *c.* 1910. The large Swiss Chalet–style house on the left, 72 South Howell's Point Road, was built in the early 20th century for Commo. Francis Holmes by the local firm Armstrong and Pierman. (Courtesy Bellport-Brookhaven Historical Society.)

Main Street is seen from the east *c.* 1910. The building on the right now houses the Bellport Restaurant. (Courtesy Bellport-Brookhaven Historical Society.)

This early-20th-century view shows the traffic warden's house, located at the Four Corners intersection of Station Road, Bellport Lane, and South Country Road in Bellport's commercial center. The gentleman is Lou Gerard, who grew up at 22 Bellport Lane, reportedly a man with a great sense of humor. The picket fence in the background enclosed the property of Capt. Edward Osborn. (Courtesy Bellport-Brookhaven Historical Society.)

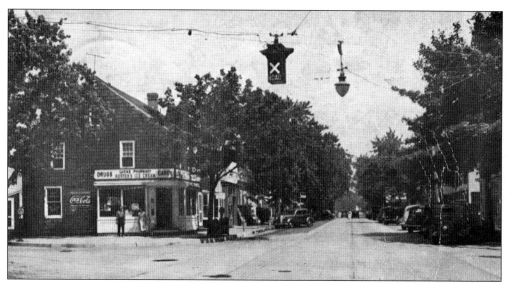

The traffic warden at the Four Corners was replaced by a traffic stanchion, which was soon replaced by a traffic light. This postcard view, looking east, shows the Four Corners in 1947. The building on the left (where Lucas Pharmacy was located and the Donna Waters Store is today) was known as Howell's General Store. It dates from 1902 and has always been painted red. A store belonging to Howell stood on this same corner spot in 1858. (Courtesy Bellport-Brookhaven Historical Society.)

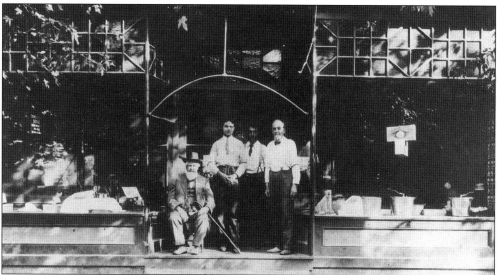

Bellport's general store in the 1880s was operated by Capt. Simeon Hulse (seated) and his brother Capt. Jim Hulse (far right). Located at the southwest corner of the Four Corners, the building was built by Capt. Edward Osborn's widow in 1884. In 1894, a wing was added to the west end of this store to be used exclusively as a post office. Prior to this time, it was customary for the post office to be located in the home of the postmaster or, if he had a business, in his store. It was in this new post office that the first telephone in Bellport was installed. This shingled building, housing the Bellport Deli, is the eye-catcher one sees on entering Bellport's center from Station Road. The large, glass-windowed storefront seen here has been replaced with bricks and smaller windows. (Courtesy Bellport-Brookhaven Historical Society.)

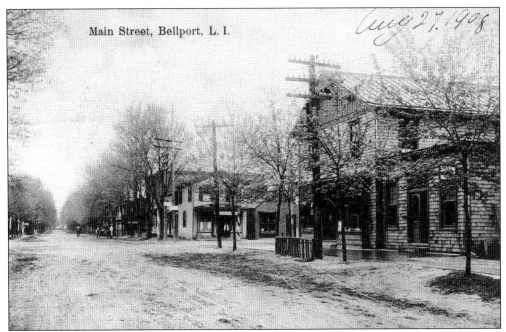

This view of Main Street looks east from a point just west of the Four Corners *c.* 1908. The Hulse store can be seen in the foreground; the building was about 20 years old then. The small corner building in the center of the picture was destroyed by fire and was replaced with an appropriately scaled building that fit in perfectly with its environment. Today it is home to Old Purchase Properties. (Courtesy Dr. Richard Berman.)

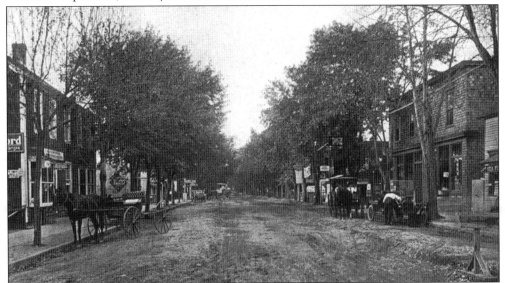

Main Street is seen from the west at the Four Corners *c.* 1908. On the left is Howell's General Store. The building on the right housed a hall on the second floor that was used occasionally as a playhouse and for card playing. This building later became the home of the Roulston Grocery Store. Today it houses the South Country Cleaners and Bellport Stationery. These buildings are so familiar to residents that it is hard to imagine Bellport without them. (Courtesy Dr. Richard Berman.)

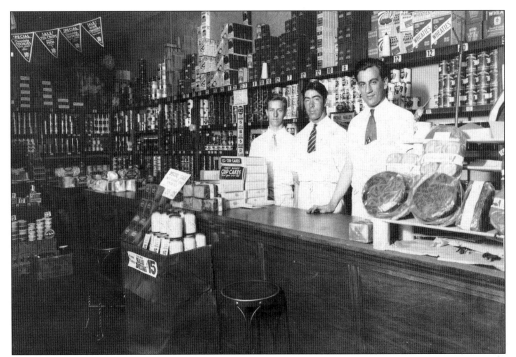

Posing behind the counter of the Roulston Grocery Store in 1933 are, from left to right, Al Kinsella, Robert Lyons Sr., and Michael Wallen. The store was located on the south side of the street across from the Comet Theater. Later, Roulston would buy the Comet Theater building, move its business there, and, in 1949, sell out to Mike Wallen. (Courtesy Robert Wallen.)

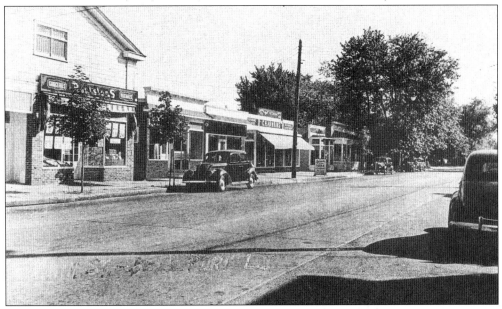

The Roulston Grocery Store is shown at its second location in this 1940s view of Main Street. It is now Wallen's Supermarket and was once the Comet Theater. Irving Berlin performed his big hit "Yip-Yip Yaphank" there in 1917 while he was stationed in nearby Camp Upton. In 1942, the building to its right was the post office. (Courtesy Dr. Richard Berman.)

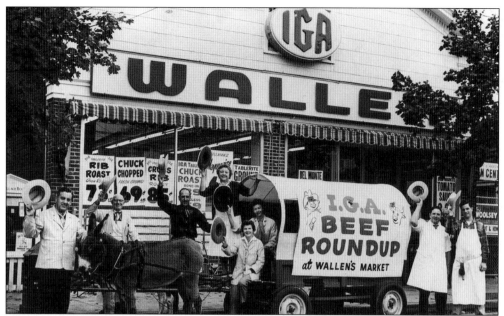

A beef promotion at Wallen's is shown c. 1960. From left to right are Mike Wallen, Martin O'Reilly, Frank Tschinkel, Esther Von Etons, Mary Wallen, Ginny Valentine, Bill Harrow, and Bill Wallen. (Courtesy Robert Wallen.)

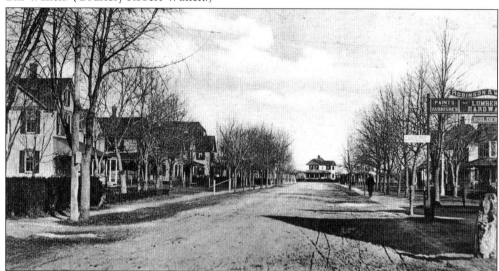

In this picture of Bell Street (looking east in 1908), we can see on the right the sign for the Robinson and Watkins building, which stands just east of the Davis Livery on the same side of the street. The Robinson and Watkins building later became known as the Brown Building because of the eccentric hardware store operated there by Ralph Brown until 1980. Today it is the shop of David Ebner. Both the Brown Building and Davis Livery date from the second half of the 19th century. At the turn of the century, the Robinson and Watkins firm was conducting a flourishing building business that was responsible for, among other things, the Catholic church in 1904, the many bathhouses of the Bellport hotels and clubs, and the development of Bell Street. The building was renovated in 1986 and became the property of the Bellport-Brookhaven Historical Society. (Courtesy Dr. Richard Berman.)

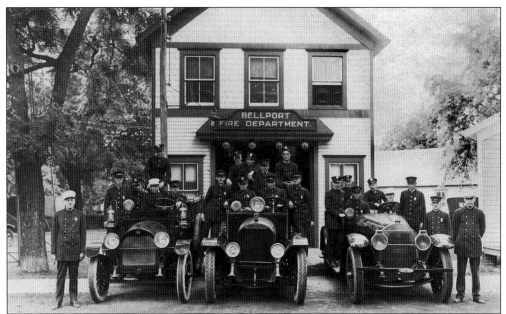

The Bellport Hook and Ladder Company was founded in 1893. The above photograph, taken c. 1928, shows the firefighters in front of the first firehouse in its original location on South Country Road, just where the present firehouse, pictured below in the late 1930s, stands. When the new firehouse was built in 1937, the little wooden firehouse was moved behind the new structure with its front facing Woodruff Street. In 1976, when the 1937 building was enlarged, the little firehouse was moved to Bell Street. Standing on the far left is Chief Everett Price. In the left truck are, from left to right, Harold Penny, Ralph Brown, two unidentified, and Everett Brown. In the center truck are, from left to right, the following: (front row) Jack Richards, Stanley Piermann, Joe Perino, and Charles Remple; (back row) Danny Hulse, Roy Hamlyn Jr., Charles Perino, and Forrest Bumstead. In the right truck are, from left to right, Leslie Raymond, Winfield Brown, Martin O'Connell, Will Armstrong, Robert Sherman, Gerald Hassell, James Watkins, and George Piermann (standing). (Above and below courtesy Bellport-Brookhaven Historical Society.)

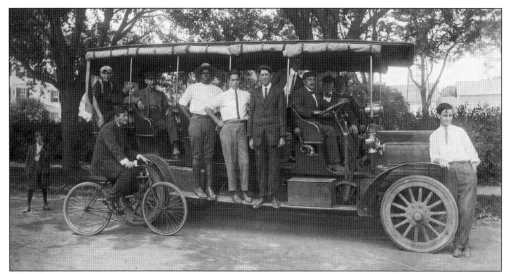

The first bus line was established in Bellport *c.* 1915 and ran between Bellport and Patchogue. This picture was taken on Bell Street in front of the stable shed next to the Davis Livery, by this time known as Murdock's Livery, where the bus was stored when not in use. The bus was owned and operated by Leslie B. Raymond, shown seated next to Carl, the driver. The little boy on the far left is Gardiner Hulse. On the bicycle is George Kreamer. William Hulse is seated on the bus to the right of George Kreamer. Standing on the running board are, from left to right, unidentified, Leroy Robinson, and Charles Cessman. Leaning on the front fender is William Sinn. On the far left we can see the rear of the Bell Inn. On the right over the hood is the barn that later became the Pierman Barn and eventually the museum of the Bellport-Brookhaven Historical Society. (Courtesy Bellport-Brookhaven Historical Society.)

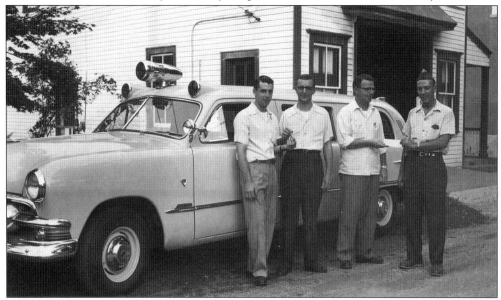

This picture shows Bellport's first ambulance, purchased in 1955 and stored in the old firehouse when it still was on Woodruff Street. The men, from left to right, are George Hawkins, Edwin Pils, Robert McCleary, and Conrad Heede. The ambulance company now occupies its own building on Cottage Place. (Courtesy Bellport-Brookhaven Historical Society.)

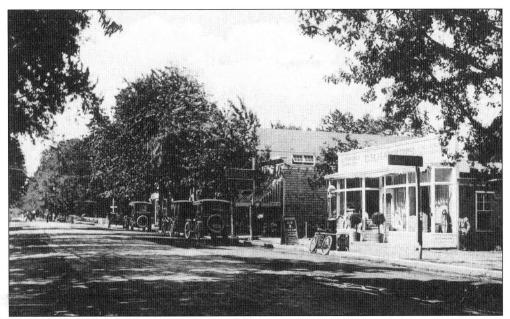

Main Street is pictured in a view looking northwest in the early 1920s. The store on the right is the Charlie Hawkins ice-cream parlor, which also sold gasoline from a pump outside its front door. The tall building to the west is the Comet Theater, now Wallen's Supermarket. Alleys on either side of the Hawkins store led to a gasoline station that Charlie owned on Station Road and that his son Clarence managed. The Hawkins store is now home to Kitchen and Coffee and the Outrigger. (Courtesy Bellport-Brookhaven Historical Society.)

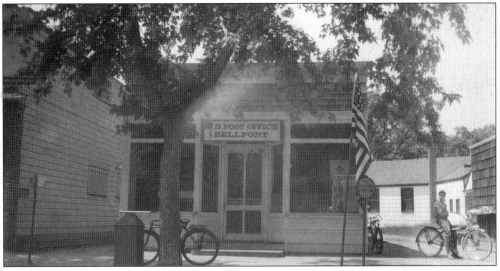

This 1942 photograph shows the village post office when it was located at 137 South Country Road next to the second location of the Roulston Grocery Store. The storefront is now home to the Four Seasons Salon. On either side of the building are alleys leading to Station Road; there was also a third alley farther east. The space on the right of the post office was once partially occupied with Frank Trotta Sr.'s newsstand and is now filled in with a building that houses the Sou'wester Bookstore. (Courtesy the Allen family.)

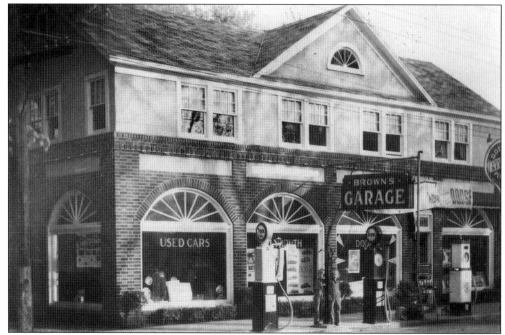

This is a photograph of Brown's Garage in 1933, an automobile showroom until the late 1980s. It is now home to the Bellport Antiques and Design Center. The two little boys standing in front are Dick and Bobby Brown. (Courtesy Emily Czaja.)

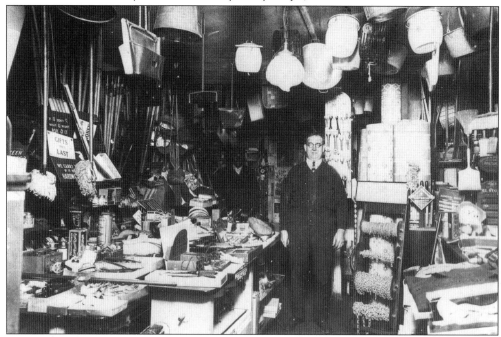

Skip Albin, pictured here in the 1940s, operated an odd-lot store at 12 Bellport Lane for many years. Anything you wanted he could get for you. Customers often wondered how Skip could find anything in his very cluttered store. Today the store is occupied by Swan Realty. (Courtesy Emily Czaja.)

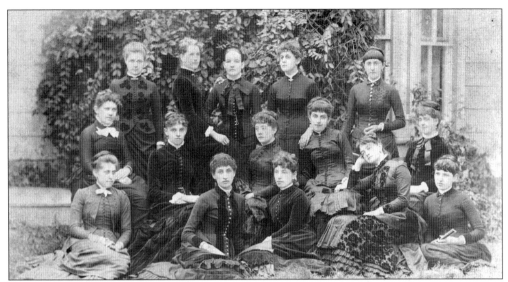

The Girls Ric Rac Society of Bellport was active in the late 19th century. It was a social organization involved with the production of rag rugs, usually to raise money for a cause. The young ladies would cut rags to strips about one inch wide and sew one end to another strip end until they would have a long enough strip to produce a ball 12 inches in diameter. The rag ball would then be sent to a Coram factory owned by the Hawkins family for the final production of a rug. Some of those shown in this July 1885 photograph are Frances Platt Goldthwaite, Emma Selover Ritch, Augusta Selover Smith, Kitty Platt Post, Almira Selover Tuthill, Nettie Loicks Watkins, Mary Camerden Gardiner, Hattie Hulse, Martha Shaw Hawkins, Emma Allison, and Josephine Post Homan. (Courtesy Bellport-Brookhaven Historical Society.)

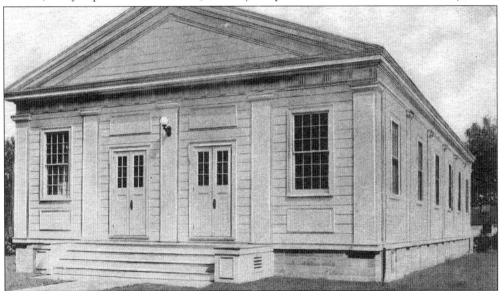

The Bellport Community House on Bell Street was built in 1926 in Greek Revival style. Lucy B. Mott provided half the funds for its construction; the rest came from public subscription. In 1967, a portico and columns were added. The auditorium has a stage and, in the 1940s, was home to the Bellport Summer Theatre. A bowling alley occupies the basement. (Courtesy Bellport-Brookhaven Historical Society.)

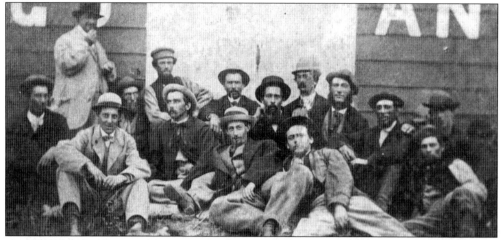

This photograph was taken *c.* 1870 near the Post and Raynor store, run by Capt. Edward Osborn. It was at the southwest corner of Bellport Lane and South Country Road. In the 1890s, the store was moved and became part of the Wyandotte Garage. From left to right are Carman Robinson, "Uncle" Ed Osborn, George Rose, Zaphas Tooker, George Munsell, William Woodruff, Ed Gerard, Henry Osborn, Platt Conklin, Joel Lee, Richard Gerard, Charles Mills, James Hawkins, Dan Rider, and two unidentified. (Courtesy Bellport-Brookhaven Historical Society.)

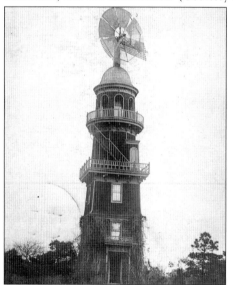

Left: This elaborate windmill, shown *c.* 1906, once stood on an estate known as Old Kentuck, owned by Col. William H. Langley. After World War II, this property, opposite the Gateway on South Country Road, became one of the first developments in Bellport. It was named Bay Harbor by the developers; Bellporters hated it and immediately nicknamed it "Alcatraz" because of the one-story cement blockhouses built there. (Courtesy Bellport-Brookhaven Historical Society.) *Right:* Considered by many to be eccentric, Osborn Shaw, Brookhaven's town historian, was a meticulous researcher with a perfect memory. He lived in Bellport in the large house inherited from his father at 197 South Country Road; he later moved to Bell Street. He was keenly interested in the history and welfare of Bellport Village and Brookhaven Hamlet, often contributing articles to the *Long Island Forum*. He hoped that one day the hamlet would readopt its ancient name, Fire Place. He died in 1959. (Courtesy Emily Czaja.)

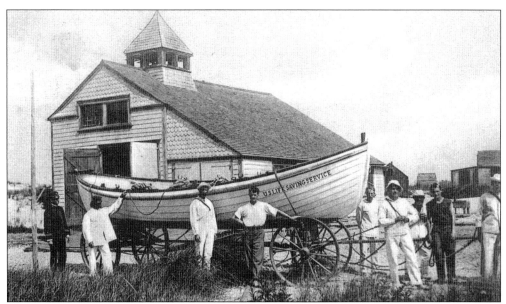

Over the years, there have been many ships that have foundered and sunk off Fire Island. After 1871, the U.S. Life-Saving Service organized lifesaving stations along the coastline, including Fire Island. The first keeper of the Bellport station, known as Station No. 14, was George Robinson. In 1915, the Coast Guard was formed and the Bellport Life Saving Station became Coast Guard Station No. 79, situated near Whalehouse Point. The stations had lifeboats, equipment to communicate with ships in distress, and lifelines to haul passengers to shore. This postcard shows the Bellport Life Saving Station with its crew c. 1908. (Courtesy Bellport-Brookhaven Historical Society.)

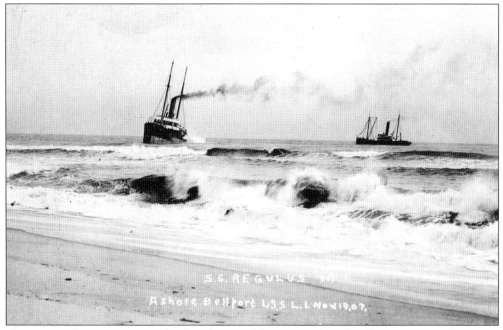

This postcard commemorates the foundering of the SS *Regulus* off Bellport in November 1907. (Courtesy Dr. Richard Berman.)

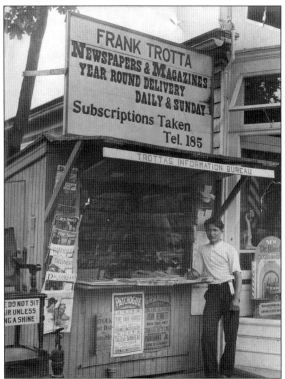

Frank Trotta Sr. started in business with a newspaper stand and shoeshine service. He is pictured here in front of his second stand in the 1930s. His first, smaller stand was in the same location on the north side of South Country Road (just about where the bookstore is now), as was his third stand, which was actually a small walk-in store. During World War II, Frank Trotta would display postcards sent to him by servicemen. Just east of his store was the Charlie Hawkins ice-cream parlor. (Courtesy Mayor Frank C. Trotta.)

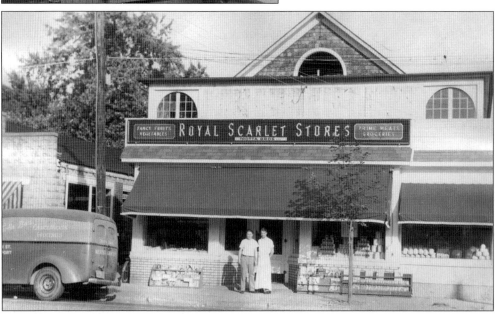

Frank Trotta Sr. and John Trotta, his brother, are standing in front of their grocery store on the south side of South Country Road in the 1940s, opposite from where Frank previously had his newspaper stand. The store was a complete, large grocery store. Frank also kept his old shoeshine stand handy and would occasionally bring it out to the street to shine shoes for a cause. A casino, or dance hall, was above the store. Today part of the building is occupied by Brookhaven Country Florist. (Courtesy Mayor Frank C. Trotta.)

Three
RECREATION

These are the things we love and know;
The briney taste of a northeast blow;
The gull-like skimming of sails beyond
The dunes at Bellport and Oyster Pond;
The rocking-chair roll of a schooner's deck;
Gardiner's Island and Shepherd'd Neck,
The Devon sumacs and Montauk Light
Turning a wakeful eye in the night.
Howell's Point and the dancing spray
Eager and fresh from Great South Bay.

—Russ Sprague Jr., former Bellport resident
From "These Are the Things" (discovered in 1965)

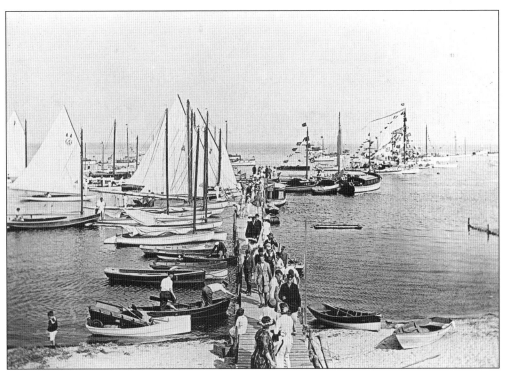

This picture shows spectators on the yacht club dock before the beginning of a regatta c. 1910. (Courtesy South Country Library.)

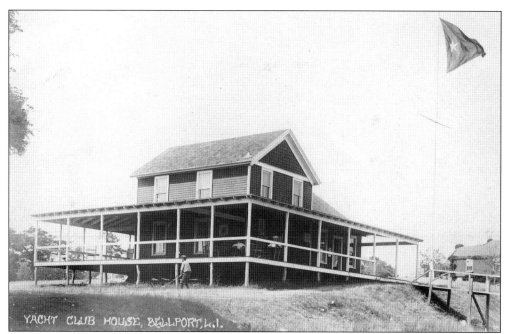

The first clubhouse for the golf club, built c. 1899, was shared with the yacht club after 1906. The building stood just west of Academy Lane on the bluff overlooking the bay. It had a long dock and steps leading down to the bay beach. When the new golf course was built, this building was then used exclusively by the yacht club. (Courtesy Bellport-Brookhaven Historical Society.)

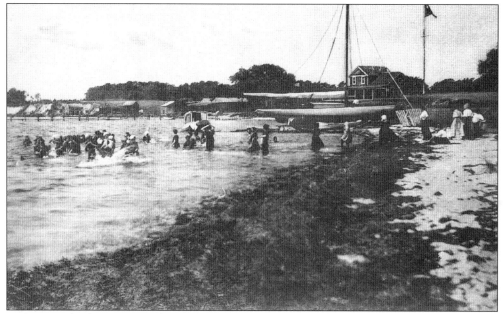

Bathing in the bay was popular in the early 20th century. The bay was deeper, cleaner, and supported a variety of mollusks. That changed when duck farms and fertilizers made their appearance, as their runoff affected the ecology of the bay. (Courtesy Bellport-Brookhaven Historical Society.)

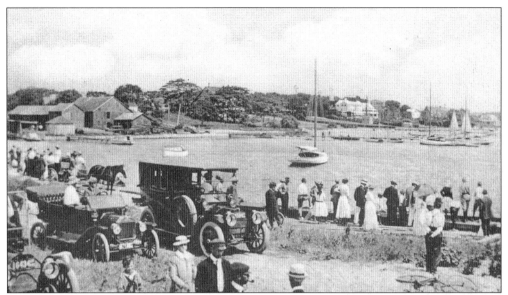

The Bellport Bay Yacht Club was organized in July 1906 at a meeting at the Goldthwaite Inn. The Committee of Fifteen on Organization was given the power to appoint the Regatta Committee in order that the club have races that very first season. The first race was held on August 4, 1906. This image shows spectators at the dock, awaiting the start of a race *c.* 1915. They are looking eastward from the foot of Bellport Lane. The dock at the time was still a natural strip of land that was improved. To the left is the Overton lumberyard. In the center left distance is the roof of the Goldthwaite Inn. The large building to the right of the sailboat's mast is a home that later became an annex to the Goldthwaite. (Courtesy Bellport-Brookhaven Historical Society.)

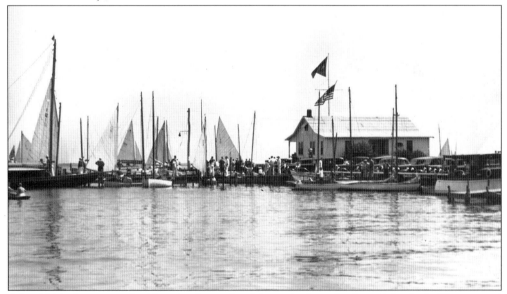

After 1921, the current building for the yacht club was built at the foot of the dock. The original clubhouse building was then moved north on Academy Lane, west of the street, and was remodeled into a home. This photograph shows the new yacht club building in its early years. It was rebuilt after the 1938 hurricane. (Courtesy Bellport-Brookhaven Historical Society.)

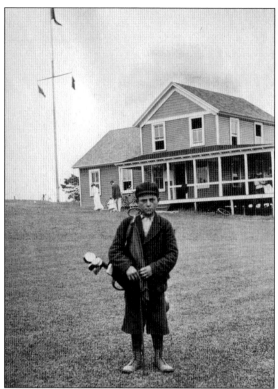

This unidentified caddy is standing to the rear of the golf-yacht club building in 1902. Bellport's first golf course consisted of nine holes and was located on land belonging to Charles Osborn. The Osborn property included the area from Osborn Avenue (now Academy Lane), west to Peat Hole pond, south to the bay, and north to South Country Road. The club was very exclusive, and its policies reflected the social restrictions of the time. The architect of the original course is unknown. (Courtesy Emily Czaja.)

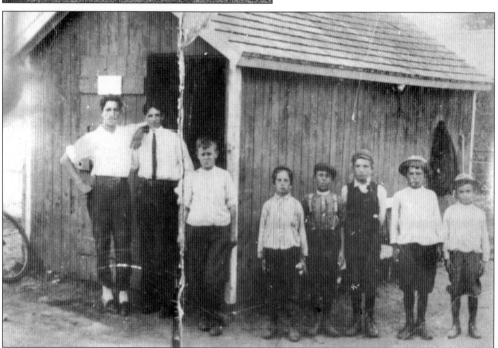

This *c.* 1909 photograph shows young caddies in front of the caddy house at the old golf course. They are, from left to right, Everett Albin, C. Floyd, Clarence Hawkins, John Schordine, Mike Fuoco, Louis Schordine, Tim Fuoco, and Louie Fuoco. (Courtesy Emily Czaja.)

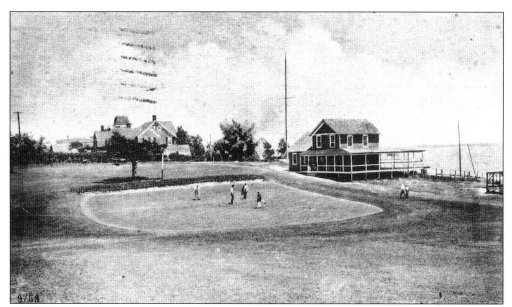

The Bellport Golf Club was founded by five men: George Barnes, John Mott, Frank Otis, Fredrick Edey, and Joseph Knapp. It was incorporated in 1899 "to provide for its members means of outdoor and indoor recreation and social intercourse." In this postcard view looking east, one can faintly discern the top of the Bay House tower in the distance on the left. In front of the tower is the private home at 2 Shore Road. The clubhouse is to the right. (Courtesy Dr. Richard Berman.)

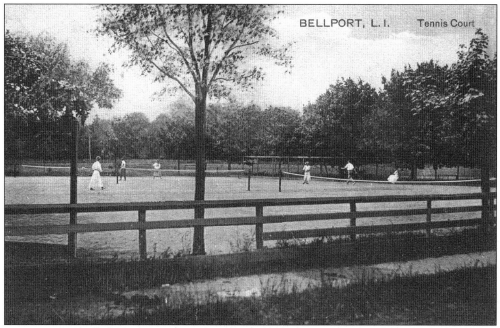

When the Bellport Classical Institute was sold and moved to the east side of the street, the land it had stood on was incorporated into the golf club and made into tennis courts. This postcard shows the Academy Lane tennis courts in 1912. (Courtesy Bellport-Brookhaven Historical Society.)

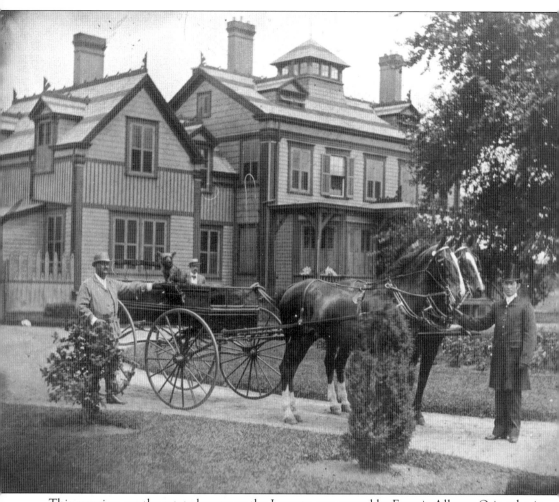

This mansion, on the estate known as the Locusts, was owned by Francis Alleyne Otis, who is pictured here standing next to his carriage in 1879. The mansion was transformed into a clubhouse by the firm Armstrong and Pierman when the Bellport Country Club, at first known as the Suffolk Golf Club, came into existence. The original nine-hole golf course closed in 1916. Plans for a new course and club were announced by Bernard Baruch, the New York financier who summered in East Patchogue, and Fredrick Edey, his friend and one of the founders of the original course. Baruch had purchased the 140-acre Lyman estate, which was adjacent to the Locusts. Francis Alleyne Otis was the uncle of Birdsall Otis Edey, his friend's wife. The two men envisioned an 18-hole course on the two combined properties with the mansion as a clubhouse. Because he was Jewish, Baruch was denied membership at the original golf club. (He also could not be a member of the Old Inlet Club, the beach club.) The purchase of the Locusts was financed partly by Edey and Baruch and partly by public subscription. It was finalized in 1917, and Seth Raynor was hired as architect of the new course. The elegant mansion was razed in 1954 and was replaced with a late-20th-century pastiche. (Courtesy Natalie Paige.)

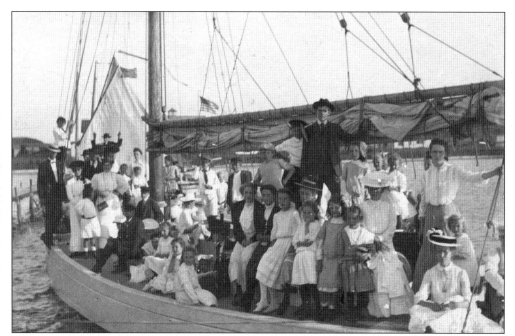

In the early 20th century, people from Bellport and Brookhaven Hamlet went on day excursions to the beach. They often went to what was known as Taffy Point because of the wonderful saltwater taffy that was made there by Carrie Hawkins, wife of Capt. Charles Hawkins, operator of the bathing beach and pavilion there. This photograph, dated 1906, shows a group leaving one of the Bellport's docks and going to the beach. (Courtesy Bellport-Brookhaven Historical Society.)

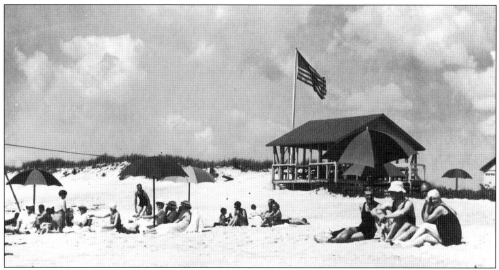

In 1910, the Old Inlet Club was founded at the Taffy Point location. This photograph, showing the members and pavilion, was taken sometime in the mid-1930s, before the 1938 hurricane. In the group to the right are, from left to right, unidentified, ? Garvin, Ira Downs, and Mrs. Ira Downs. The club was ramshackle compared to other beach clubs on eastern Long Island. Nevertheless, it was just as exclusive, and its admission policies mirrored the social prejudices of the period. (Courtesy Bellport-Brookhaven Historical Society.)

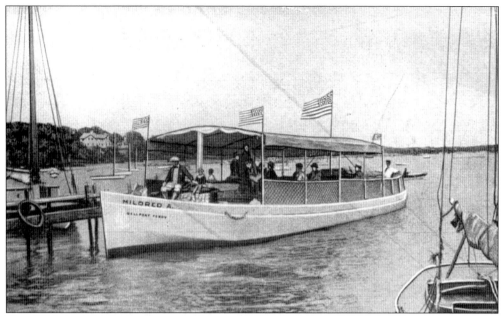

The Old Inlet Club had an irregular ferry to the beach before 1914. From 1914 to 1945, there was the *Mildred A.* (shown here) and the *Ruth.* Wilber Corwin was the skipper of the *Ruth,* originally a sailboat that he converted to a powerboat and ferry. Ray Davis captained the *Mildred A.* (Courtesy Bellport-Brookhaven Historical Society.)

This undated picture shows Wilber Corwin seated on his *Ruth.* (Courtesy Bellport-Brookhaven Historical Society.)

This sailboat, photographed c. 1902, was probably the *Mabel Jewel*, which was owned by Wilbur Corwin and used by him to ferry passengers to the beach before he purchased the *Ruth*. The *Mabel Jewel* was the only fantailed boat on the bay. The man sitting on the dock is Capt. Charlie Hawkins. (Courtesy Bellport-Brookhaven Historical Society.)

Old Inlet Ferries

"MILDRED A"

Morning and Afternoon Between

Bellport and Old Inlet

Beginning June 19th

Weekday and Sunday Schedule

Leaves: **Bellport** *10:30 a.m.* - *2:30 p.m.*
Leaves: **Old Inlet** *12:30 a.m.* - *5 p.m.*

Capt. **RAY S. DAVIS**

.:. ALSO .:.

"RUTH"

Morning Ferry

Leaves: **Bellport** *10:30 a. m.*
Leaves: **Old Inlet** *12:30 p.m.*

Open For Afternoon and Evening Parties

Capt. **WILBUR A. CORWIN**

U. S. PRESS, Bellport

This poster announcing the ferry schedule to Old Inlet probably dates from the late 1930s or 1940s. (Courtesy Bellport-Brookhaven Historical Society.)

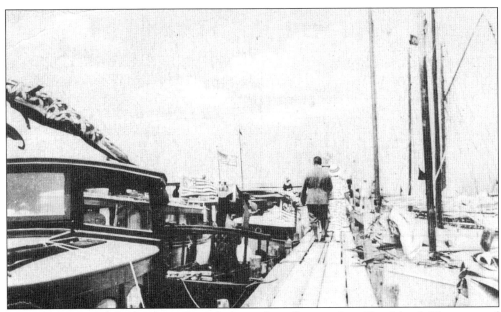

The Old Inlet Club had its own ferry docks in the village and on Fire Island. The postcard shows a crowded Fire Island dock c. the 1920s. The dock was an important part of the social scene. The private Old Inlet Club closed in the early 1970s and was replaced by the public village beach, which came to be known as Ho-Hum Beach, west of Old Inlet. The first ferry to Ho-Hum Beach was the *Leja Beach*. It was followed by the village-owned *Whalehouse Point*, which began service on May 27, 1988. (Courtesy Bellport-Brookhaven Historical Society.)

OLD INLET BEACH PARTY

Sunday, August 31, 1947

CHARCOAL BROILED STEAKS REFRESHMENTS

PRICE: $2.50 per person including ferry fare.

Ferry will leave town dock at 6:00 P. M. The Leja Beach ferry, which will carry over 100 people, has been engaged for the night. Please indicate below the number of people who will be in your party and return no later than Thursday, August 28, 1947 so that necessary arrangements can be made.

Sharmon Bush will be our Chef.

The club occasionally hosted parties, as this notice illustrates. (Courtesy Natalie Paige.)

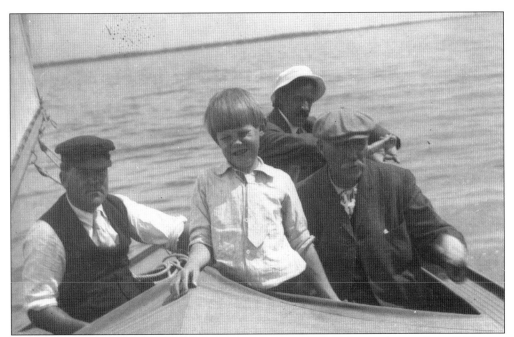

Bellporters are shown sailing aboard the *Kittery c.* 1908. From left to right are Capt. Ed Rogers (often called Uncle Rogers), Perry Bigelow, Paul Bigelow, and Dr. J.G. Noble. (Courtesy Bellport-Brookhaven Historical Society.)

Pictured on the Bellport Dock in the early 1940s are, from left to right, Pam Anderson, Capt. Ed Rogers, and Joan Earl. (Courtesy Emily Czaja.)

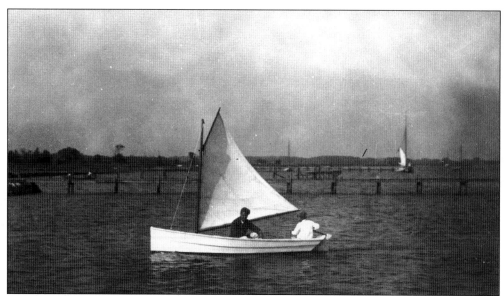

This photograph, taken c. 1910, shows Perry Bigelow learning to sail with Ransome Noble aboard a sharpie called the *Perriwinkle*. Paul Bigelow, Perry's father, made the sail and rudder for this sailboat. The picture was taken by Perry's mother from the Goldthwaite dock. The dock directly behind the sailors was a private dock owned by the Walton family. Behind that we can see the Brandreth family's dock. Beyond the Brandreth dock is the Wyandotte Hotel dock. (Courtesy Bellport-Brookhaven Historical Society.)

This picture was taken in front of the summerhouse of the old Bay House (at the foot of Bellport Lane), which was by this time known as the Jewish Working Girls Vacation Society Camp. The young lady holding the ball is Bertha Hahn, who spent two weeks in the summer of 1918 at the camp. The house on the upper left is 2 Shore Road. A simplified version of the summerhouse sits today in the same location. (Courtesy Barbara Weiser.)

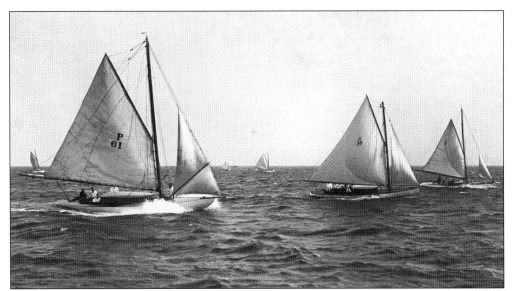

In the 1920s and earlier, a popular, grand class of boat on Bellport's waters was the P Class. These boats were large and powerful, 34 to 44 feet overall. This photograph captures P boats racing off Bellport c. 1925. The boat in the foreground was the *Bee*, built by noted boatbuilder Gil Smith of Patchogue and owned by Commo. Paul Bigelow. (Courtesy Bellport-Brookhaven Historical Society.)

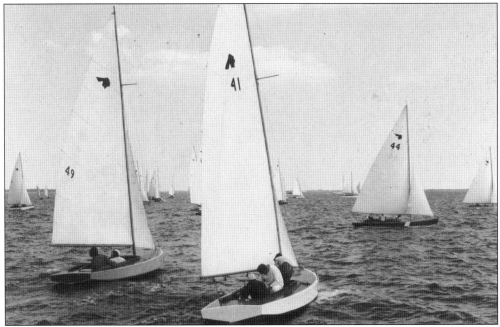

A very popular class of boat in the 1940s through the mid-1950s was the Narrasketuck Class. The boats were built by Wilbur Ketchum of Amityville for the bay and did not have a spinnaker sail. They are still made today, but in fiberglass. This picture, taken during race week in the late 1940s, shows Joan Dowd's boat (No. 49), Charlie Axtmann's *Teaser* (No. 41), Andrew Underhill's *Scud* (No. 44), and Nancy Underhill's *Buzuna* (No. 36). (Courtesy Bellport-Brookhaven Historical Society.)

This photograph was taken in the 1950s during race week. The Great South Bay race season opened and closed in Bellport. The upright white columns seen in the background behind the flag are part of the remains of the Bay House porch used as a bandstand. The tower on the right was a World War II lookout tower. (Courtesy Bellport-Brookhaven Historical Society.)

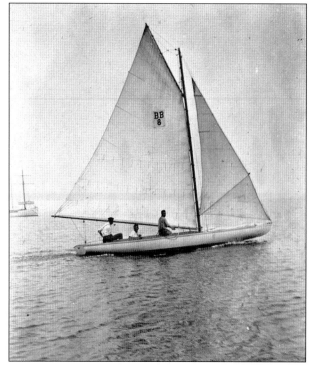

Bellport's own sailboat, the Bellport Bay One Design (or BB), was built from 1907 to 1922 at the foot of Bellport Lane at Will Overton's Boatyard. It was 26 feet overall. Pictured is one that was owned by the Murdock family. (Courtesy Natalie Paige.)

The little skipper on the left is Peter Paige, and the even smaller skipper next to him is his friend Jock Elliott. The captain on the right is unidentified. They are on the Paige yacht *John A. King* in 1923. (Courtesy Natalie Paige.)

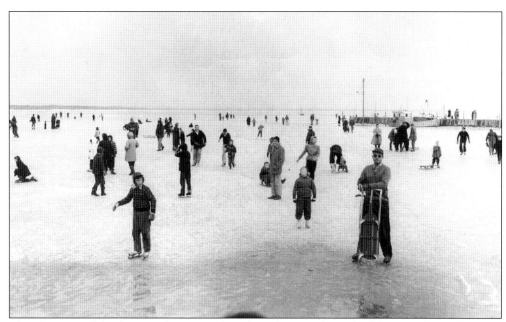

The pleasures of the bay are also enjoyed in the winter, as this 1955 photograph of ice-skaters shows. The location is just east of the village dock. The scooters, not seen in this picture, would be farther out on the bay. (Courtesy Bellport-Brookhaven Historical Society.)

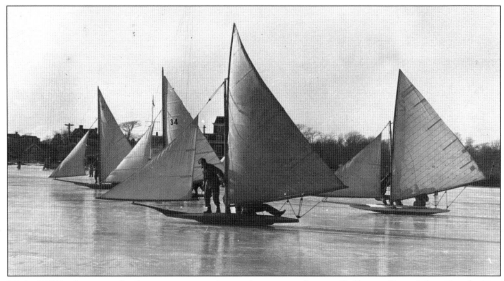

This 1950 photograph shows scooters in action on a frozen Bellport Bay. The South Bay Scooter Club, formally organized in 1924, uses the yacht club building. Behind the sails we can see familiar buildings except for the tallest building, the Bay House. At the time this picture was taken, its days were numbered. (Courtesy Natalie Paige.)

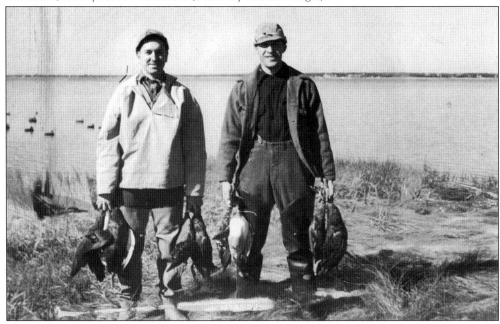

The Bellport Bay bogs have been a popular shooting ground for waterfowl since at least the early 19th century and have seen a number of hunting clubs. The Pattersquash Gunners Association was started in 1925 and rents from Brookhaven Town the exclusive right to gun over Bellport Bay. It is limited to 60 members, and one must be a voting resident of the town to become a member. The headquarters of the club during the shooting season is a little house on what is known as Pelican Island, not far from Old Inlet. In this c. 1930s photograph we see Ted Everitt (left) with Ed Austin. They are on West Bog and are holding black duck and mallard. (Courtesy John Everitt.)

Four

THE ARTS, CULTURE, AND INVENTION

*Almost everyone in art, literature, or music
appeared at Bellport sooner or later.*

—Ira Glackens
From *William Glackens and the Ashcan Group* (1957)

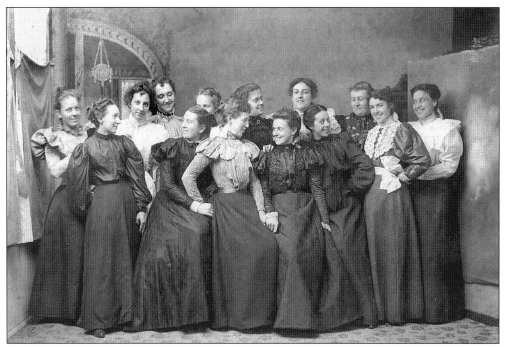

In 1897, these women decided to start a local library. Calling themselves the Entre Nous Club of Bellport, they organized a party and asked each person attending to bring a book. Sixty books were collected, forming the nucleus of the new library. As it grew, the library had several homes and, by 1908, a library board of trustees existed that planned fundraising events. From left to right are Harriet Watkins Shaw, Mary Raynor Robinson, Alberta Turner Murdock, Saddie Davis Huntting, Mrs. S.W. Toms, Louise LeMar Rogers, Augusta Selover Smith, Charlotte Watkins, Martha Shaw Hawkins, Harriet Roe Hulse, unidentified, Nettie Beers Watkins, Lily Dunham Selover, and Urania Shaw Walling. (Courtesy South Country Library.)

In 1919, a plan to honor the local heroes of the war led to the formation in 1920 of the Bellport Memorial Library Association. A design by Aymar Embury II was selected, and Lucy B. Mott donated land on the corner of Bellport Lane and Bell Street that was once Capt. Thomas Bell's apple orchard. The building was completed in 1923 and served as the library until 1986. It is now the Bellport Village Hall. (Courtesy Bellport-Brookhaven Historical Society.)

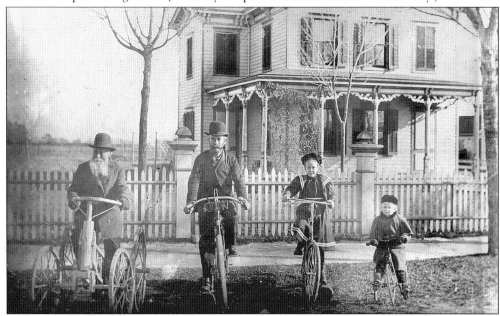

Oliver Hazard Perry Robinson is seated on his velocipede on the far left in this picture, taken c. 1895. To the right are his son Walstein E. Robinson and his grandchildren. They are pictured in front of Walstein's house, which still stands at 9 Browns Lane, looking very much like it does here. Oliver Hazard Perry Robinson, a Bellport carpenter by trade, was a hero of the Battle of Lake Erie in the War of 1812. He was also the inventor of the ball bearing, which he patented in 1866. Robinson constructed several vehicles using his ball bearings, among them the pictured velocipede. (Courtesy Prisilla Carleton.)

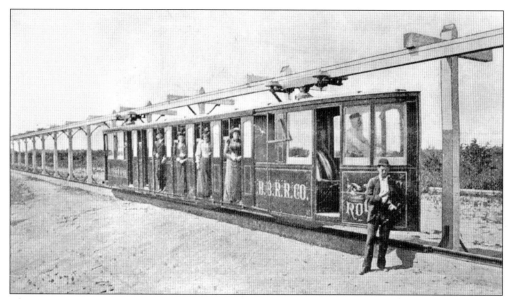

This strange-looking transport, called the *Rocket*, was the failed bicycle train that was the brainchild of F.W. Dunton and C.F. Hagerman in 1892. Planned as competition to the Long Island Rail Road, it was supposed to run extremely fast on an elevated line from Jamaica to Hagerman (just outside of Bellport) and then to Port Jefferson. The big plans never became reality, however, and the train was a complete failure. It did run for a while between Hagerman and the bay, on two wheels on a non-elevated track, and was held upright by an overhead rail. (Courtesy Bellport-Brookhaven Historical Society.)

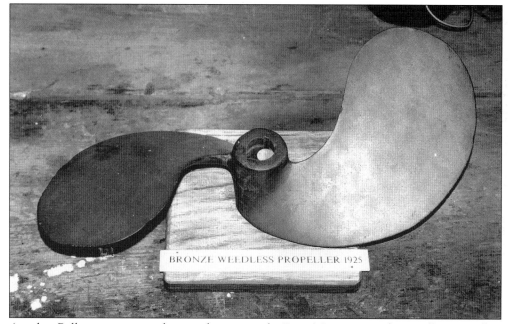

Another Bellport invention that can be seen at the Barn Museum was the weedless propeller, made *c.* 1925 by Nathaniel Roe. The propeller made it unnecessary to reverse the engines when a boat hit a patch of seaweed. (Courtesy Robert Duckworth.)

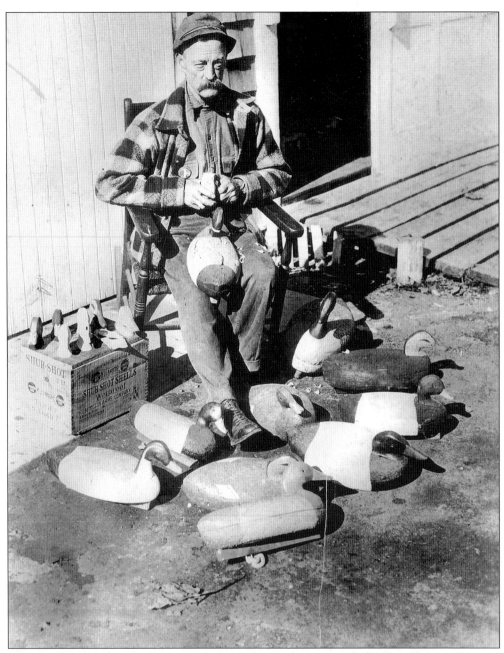

John Boyle carves his decoys *c.* 1920. In 1924, Boyle organized the Brookhaven Gunners Association, which preceded the Pattersquash Gunners Association, a hunting club. There were several accomplished carvers who lived in the Bellport-Brookhaven area from 1800 through the 20th century and whose birds are prized by collectors. The very first decoy show, credited for introducing decoys as a collectible folk art form, was held in Bellport in August 1923. It was organized by a group called the Howell's Point Anti-Duskers to educate the public on good sportsmanship. In 1973, John Boyle was one of the organizers of a show held at the Barn Museum to commemorate the 50th anniversary of that first show. (Courtesy Bellport-Brookhaven Historical Society.)

Capt. Wilbur W. Corwin in 1874 put a jib sail on a duck hunter's punt boat, beveled the runners, and streamlined its shape. This craft could easily travel over ice or water and was very useful to cross the bay quickly in freezing weather to get to a distressed ship. It was also useful for transporting baymen, waterfowl hunters, and supplies from the mainland to Fire Island. The first scooter was called the *Jib* and can be seen at the Barn Museum. This photograph, taken in the early 20th century, shows Fred Smith with his son Hervey (seated in their scooter) on a frozen Bellport Bay. Behind them left are bathhouses built by Robinson and Watkins. (Courtesy Bellport-Brookhaven Historical Society.)

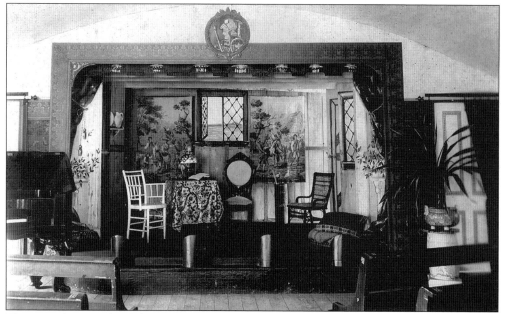

This rare photograph of the small theater at the Titus House dates from *c.* 1870. The theater was located on the second floor of an added north wing. The addition was originally the Ladies Hall of Bellport, located at the southeast corner of Academy Lane and South Country Road. (Courtesy Bellport-Brookhaven Historical Society.)

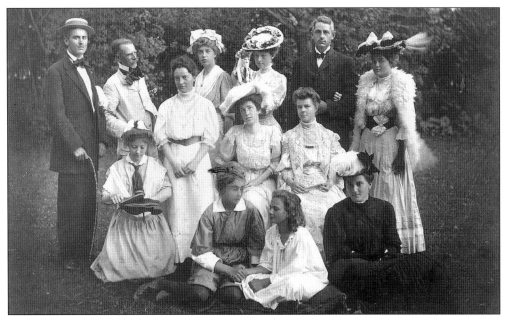

This is a group portrait of the players who acted in *Ici On Parle Francais*, *The Burglar*, and *Peter Pan*. The performances were given at Nearthebay on July 27 and 28, 1906, to benefit the Bellport Memorial Library. This photograph was taken by Bellport photographer Frances Toms. She took many wonderful pictures of Bellport at the turn of the century, sometimes hand-coloring them. (Courtesy Bellport-Brookhaven Historical Society.)

The Bellport Summer Theatre was founded at the community center and was at its peak in the 1940s. The professional actors who performed there would stay at the Bellport Hotel and socialize at the Circus Bar in the Wyandotte. Shown is a curtain call for a production on the community center stage. The actors are unidentified. (Courtesy Bellport-Brookhaven Historical Society.)

Shown is a page from the playbill of a 1945 production. The Bellport Summer Theatre waned in the early 1950s as the Gateway Playhouse came into its own. (Courtesy the Allen family.)

The
Bellport Summer Theatre
- presents -
Claudia
by ROSE FRANKEN
Directed by
JERRY BIRN

Cast
(In order of appearance)

MRS. BROWN Zelda Benjamin
DAVID NAUGHTON Jerry Birn
CLAUDIA NAUGHTON Loretta Ellis
BERTHA Julia Cross
FRITZ Freeman Hammond
JERRY SEYMOURE Lou Frizzell
MADAME DARUSHKA Lesley Savage
JULIA NAUGHTON Sally Pomeran

Scenes:
Living-room of the Naughton's country house
Act I Friday evening, Early Fall.
Act II The following afternoon.
Act III Evening of the same day.
Set designed by Jeanne Burke

For the Theatre:
Jeanne Taylor - *Business Manager*
Jeanne Burke - *Technical Director*
Al Thaler - *Ass't Technical Director*
Nina Malone - *Properties*

In this *c.* 1960 view, Harry Pomeran is standing at the rear doorway of the Stanford White–designed ballroom that Mr. and Mrs. J.L.B. Mott added to the old Charles Osborn property at the Gateway. The ballroom was used for student productions and as a dance studio, while the professional players performed in the Barn Theater. Harry and Libby Pomeran purchased the Osborn-Mott property to run a hotel for Christian Scientists. On seeing the gate, Libby Pomeran named the property the Gateway because she desired the property to be a gateway to life, truth, and love: synonymous for God in Christian Science. (Courtesy the Allen family.)

Harry Pomeran is shown with his three children in 1943 after gathering corn to feed the cow that they kept on their property. The children are David, Ruth (standing), and Sally. It was the children who started the Gateway Playhouse, first getting experience in the Bellport Summer Theatre at the community center and then putting on shows in the ballroom to entertain the hotel's guests. Finally, in the summer of 1950, in a barn on the property converted into a theater, the first official production of the Gateway Playhouse took place. The show was Shakespeare's *The Taming of the Shrew* and starred Sally Pomeran, who would be in charge of the theater through the 1950s. (Courtesy the Allen family.)

The year 1961 saw the construction of the new theater at the Gateway. By this time, the Gateway had become a Columbia Pictures talent farm. In addition to students, major stars came to perform there. (Courtesy the Allen family.)

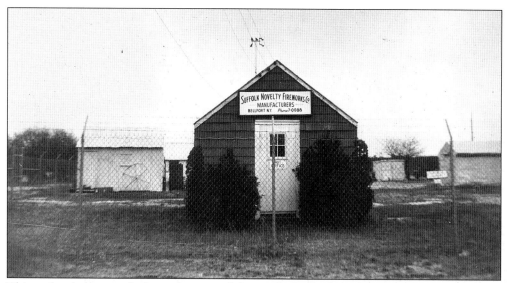

This undated photograph shows the original Grucci fireworks plant, located on 13 acres between Head of the Neck Road and Association Road in Bellport. The Grucci family tradition in pyrotechnics has its roots in mid-19th-century Italy with Felix Grucci Sr.'s grandfather. Felix Grucci Sr. started the Bellport business in 1929 as the Suffolk Novelty Fireworks Company, and the business remained at its original location until 1983, when it moved to a larger campus in Brookhaven. In this picture, the office is the middle building and the buildings on the left and right are fireworks factories. Leaning on the wall of the left building is a pinwheel, an early pyrotechnic design that would spin around with various fiery colors. (Courtesy the Grucci family.)

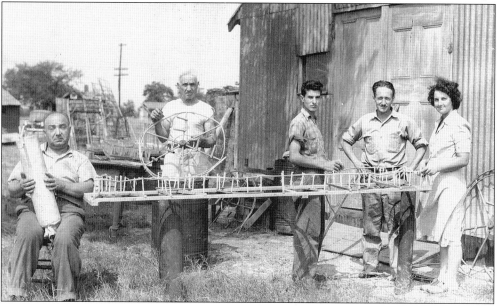

This 1952 photograph shows, from left to right, Nick, Joe, Ernie, Felix Sr., and Concetta Grucci working on a set piece (a stationary grid that forms the outline for wording in a fireworks display). Nick is holding a break-shell, a device that shoots up and breaks into rainbow colors, and Joe is holding a pinwheel. The view is north and the group is standing in front of building No. 2 at the old fireworks plant. (Courtesy the Grucci family.)

Felix Grucci Sr. is shown in the early 1950s on Fire Island with his rocket and rocket launcher, part of the first stage of a program developed at the request of the federal government to simulate an atomic bomb. The second stage was the development of a drop burst bomb, a simulated atomic device dropped from an airplane. These simulated atomic bombs were used by the armed forces for training in radioactive defense tactics. (Courtesy the Grucci family.)

This 1955 image shows Felix Grucci Sr. on Fire Island with a ground-detonated simulated atomic device that represented the final stage. Its purpose was to simulate at a reduced scale the visual and auditory effects of an atomic explosion. Felix Grucci Sr. was truly a master of his art. In addition to the simulated atomic bomb, he also invented the stringless shell, a landmark innovation for the fireworks industry that eliminated its greatest safety problem, burning fallout. His firm, now called Fireworks by Grucci, won the gold medal for the United States at the annual Monte Carlo International Fireworks Competition in 1979. The firm was also involved in six consecutive presidential inaugurations and the centennials for the Brooklyn Bridge and the Statue of Liberty. (Courtesy the Grucci family.)

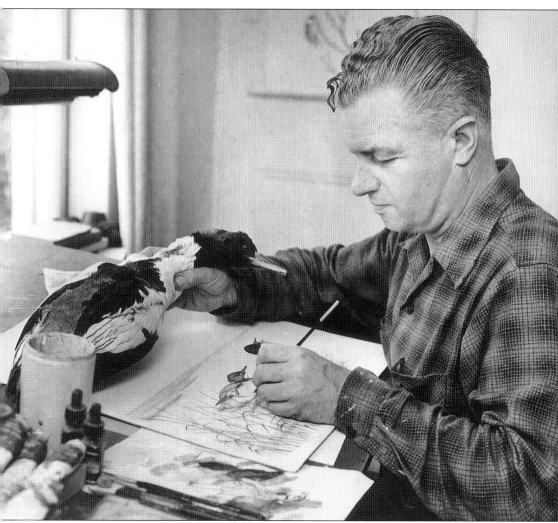

Pictured in his late fifties, Dennis Puleston paints a merganser in his home studio on Meadow Lane. Puleston—lecturer, boat designer, naturalist, and founder of the Environmental Defense Fund—was an ornithologist, artist, and the head of information and publication at Brookhaven National Laboratory. He accomplished the amazing task of painting every bird on Long Island and was often seen conducting bird walks both locally and elsewhere. A major influence in educating people on the beauty, importance, and fragility of the natural environment, he wrote three books: *Blue Water Vagabond* (1939), which describes his travels between 1931 and 1937; *A Nature Journal* (1992), which he also illustrated; and *The Gull's Way: A Sailor's Naturalist Yarn* (1995), written when he was 89. In *A Nature Journal,* he wrote: "Long Island is so much more than shopping malls, concrete highways, and crowded towns and beaches. There are still cool woodlands, quiet rivers, salt marshes, overgrown meadows, and rolling sand dunes to be enjoyed by those who have eyes to seek and the desire to learn about the other Long Island, the one that existed long before the first settler broke ground." (Courtesy Betty Puleston.)

This rare photograph of two Ashcan School artists at the Old Inlet Club was taken in 1911 by Julia Edey Paige, daughter of Birdsall Otis Edey. Partially visible to the far left is Florence Scovel Shinn, wife of Everett Shinn. In the middle is Everett Shinn, and to the right is William Glackens. From 1911 to 1916, William Glackens spent five summers in Bellport and one in Brookhaven Hamlet. During this time, he painted many scenes of Bellport. Several canvasses depict New York shop girls bathing at the shore front of the Jewish Working Girls Vacation Society Camp. Glackens was often visited by fellow Ashcan artists, such as the Shinns, Ernest Lawson, and Maurice Prendergast. Sometimes, Glackens and Shinn were involved in dramatic productions for the library's benefit at Mrs. Edey's Nearthebay Playhouse. A melodrama written by Shinn (*Hazel Weston; or, More Sinned Against than Usual*) was produced there in 1911 and starred the Glackens and the Shinns. (Courtesy Dr. Richard Berman.)

Five

HOUSES ON THE LANE AND OTHER HISTORIC HOMES

*Bellport's considerable beauty, as with most exquisite things, is a function
of a million things, a complex mosaic of details: colors, angles, proportions,
size, positions, etc. And as is true of many beautiful things, Bellport's
beauty is a fragile and easily marred countenance. It is also easily taken for granted. . . .
Life in Bellport is a gift; living in Bellport is a responsibility as well as a joy.*

—Horace Gifford
From a letter to the *Long Island Advance*, August 10, 1989

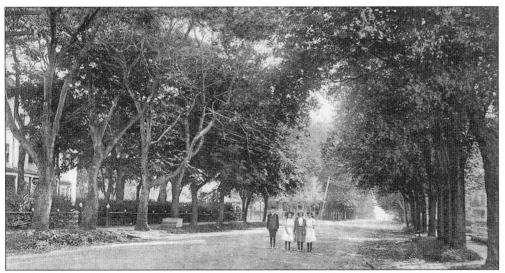

Children pose on an unpaved Bellport Lane *c.* 1908. On the left is the Bell Inn. The small steps
near the curb were used for stepping off a carriage when arriving at the hotel. This postcard
reflects the distinctive street we see today: an appealing, architecturally harmonious country
boulevard sweeping down to a glorious bay. This chapter may be used for a walking tour of the
lane that became a historic district in 2001. (Courtesy Bellport-Brookhaven Historical Society.)

This hip-roofed home at 31 Bellport Lane was built in 1833 by a shipbuilder named Hiram Post, who was one of the partners in the Post and Raynor shipbuilding firm. The foundation of this house is made of stone that was probably used as ballast for homebound Bellport ships. The last person to own this house was Florence Crowell, who deeded it to the Bellport-Brookhaven Historical Society. The house, now a museum known as the Post-Crowell House, is the centerpiece of the Bellport-Brookhaven Historical Museum complex, which also includes the Barn Museum, the Ralph Brown Building, the Blacksmith Shop, the Emilie R. Underhill Studio, the Milk House, the Exchange Shop, and the Edward Osborn Gazebo. (Courtesy Bellport-Brookhaven Historical Society.)

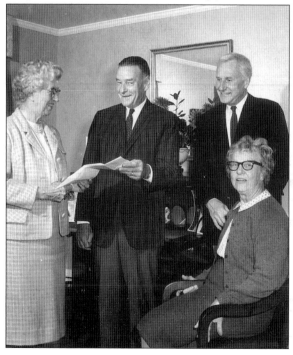

In 1967, Florence Crowell deeded her house to the Bellport-Brookhaven Historical Society, reserving the right to occupancy during her lifetime. She is pictured here to the left handing the deed to Robert Pelletreau, the second president of the society. Also pictured are Laurence Fuller and Ruth Morse. The society was organized in 1958 as the Bellport Historical Society and received its permanent charter in 1963. Its name was changed to the Bellport-Brookhaven Historical Society in 1966. The purpose of the society is to preserve and promote the historical heritage of the Bellport and Brookhaven area. It is actively engaged in various projects to accomplish and perpetuate this purpose. (Courtesy Bellport-Brookhaven Historical Society.)

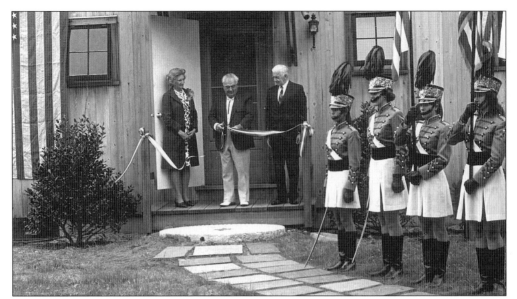

On September 24, 1972, the grand opening and dedication ceremonies for the Barn Museum were held. Pictured is the ribbon-cutting ceremony. Stephanie Bigelow, curator, and Preston Bassett look on as Mayor Harry Bedell does the honors. The color guard of the Phantom Regiment of Brookhaven stands at attention. The museum building was formerly a livery stable on the Bell House property and was later used by the firm Armstrong and Pierman, builders of several fine homes in Bellport. It was moved to its present site from the opposite side of Bell Street in 1968. (Courtesy Bellport-Brookhaven Historical Society.)

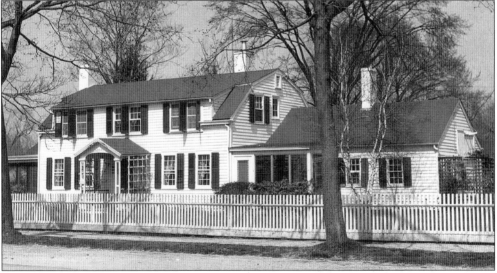

The house at 33 Bellport Lane was built c. 1831 by Jacob Bell, father of Thomas and John Bell, on land purchased from the Hulse family. It is often mistakenly referred to as Capt. Thomas Bell's home. Thomas and John Bell shared a large home with their families (north of this) that was enlarged into a hotel and torn down in 1933. The village parking lot is now there. This gambrel-roofed house—with a continuous, six-windowed dormer across the front—was the summer home of Genevieve Earle, the prominent Brooklyn politician, who together with Florence Crowell began the Bellport Archives. (Courtesy Bellport-Brookhaven Historical Society.)

The Bellport Gate is special for the design of its sweeping wrought-iron hardware created by local blacksmiths Joseph Shaw and his son Charles. They were made in the Shaw blacksmith shop on Academy Lane from the late 19th century through the 1920s. In the 1930s, they were made in the Shaw shop on New Jersey Avenue. Many homes in Bellport with picket fences still have the unique hardware, their owners carefully reinstalling them whenever a fence needs to be replaced. (Courtesy Robert Duckworth.)

The original part of 35 Bellport Lane was built by Capt. Charles Hulse c. 1870 on land owned by his wife's family, the Riders. Hulse was known as one of the few Bellporters who had sailed the old windjammers, long-distance oceangoing vessels. The Hulses rented the house during the summers, adding rooms as needed. The house was sold and remodeled c. 1900 and then again in 1923 after being purchased by John and Mary Ewing Jr. They hired architect Eddy Fairchild, who was influenced by the architecture of Charleston, South Carolina, and who added the double porch on the south side of the house. (Courtesy Tom Binnington.)

Capt. Charles Rider built this house at 37 Bellport Lane *c*. 1858 on land he purchased from Capt. Thomas Bell. The house changed dramatically in appearance after the extensive remodeling done in 1890 by Charles Rich, who purchased the house from Charles Rider. It is a distinctive house with a large gambrel front facing the street. The house was left by Charles Rich to his daughter Emilie Underhill. It remained in the Underhill family for many years. (Courtesy Bellport-Brookhaven Historical Society.)

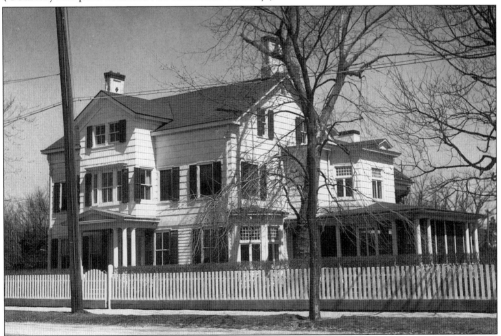

The original section of 39 Bellport Lane dates from *c*. 1844 and was built by David Rose. In 1904, it was purchased by the Raven family, who raised the house and added a new first floor, making it a two-and-a-half-story structure. In 1912, it was again enlarged and remodeled when purchased by Olivia Young. Her architect was her neighbor, Charles Rich; the builder was Robinson and Watkins. (Courtesy Bellport-Brookhaven Historical Society.)

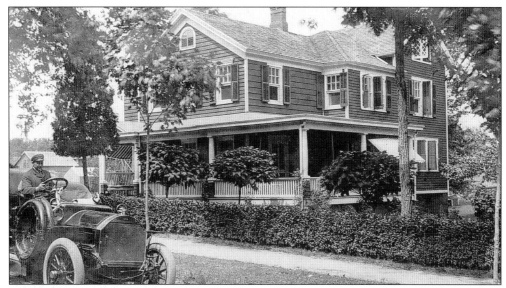

The house at 43 Bellport Lane stands at the site of an earlier home belonging to Capt. Isaac Homan, who built boats in his backyard and then dragged them either on rollers or greased rails to the bay. Not all the boats made in Bellport were produced in Bellport shipyards. The house later became the property of Thomas Griffing, owner of the famous Bay House. In 1900, the original house was torn down. Pictured here c. 1915, the present house (a gable-front-and-wing design) was built by George Droste and was later enlarged by his daughter through the Bellport firm of Armstrong and Pierman. (Courtesy David Meitus.)

Built c. 1890 by Capt. John Rider, 47 Bellport Lane has been enlarged twice and now appears as a modified gable-front-and-wing design. For many years, Capt. Sam Petersen, William Francis Gardiner's son-in-law and Danish immigrant, lived in this house. Petersen was a bayman and fisherman who was especially known for his eel catch. He also occasionally worked on the *Bilicon*, which was owned by Col. William H. Langley, who lived at the estate Old Kentuck, just east of the village. (Courtesy Robert Duckworth.)

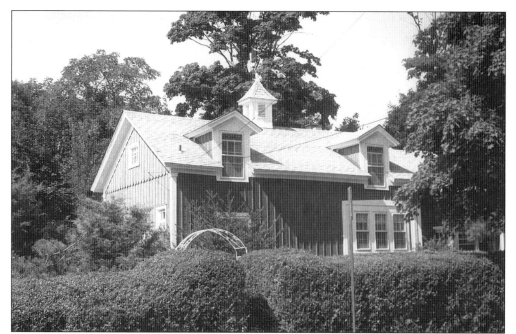

In looking at 54 Bellport Lane, one must consider the story of the house looming directly west of it up on the bluff at 37 Academy Lane. This barn, with Greek Revival details, was once a carriage shed for that property. It was remodeled into a home in the 1930s by the Elliot family, who owned both it and the Academy Lane house for many years. (Courtesy Robert Duckworth.)

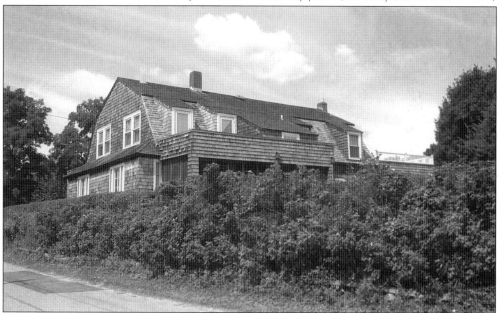

The Shingle-style house at 37 Academy Lane was known as the Flower Box for the rambling roses that grew nearby. It was built in the 1890s by Josefa Neilson Osborn, fashion arbiter, inventor of the shirtwaist, and costumer of Ethel Barrymore. The house served as a "sleeping house" for overflow guests of what was then the main house of the property just east across Shore Road. (Courtesy Robert Duckworth.)

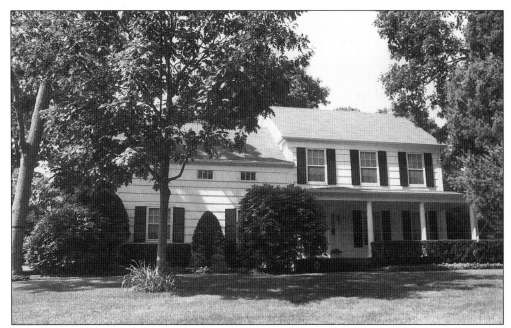

This home at 50 Bellport Lane is not an antique but rather a respectful newcomer. It illustrates the architectural harmony that can be achieved when the context of neighborhood is not ignored but celebrated. This academic Greek Revival house, with careful attention paid even to the smallest detail, was built by a local contractor in 1963. (Courtesy Robert Duckworth.)

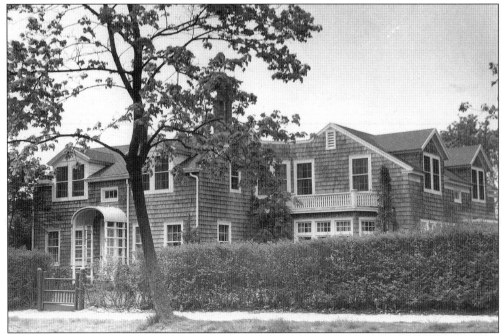

The grey-shingled house at 46 Bellport Lane was once owned by the playwright Kirk La Shell. It was built before 1858, the property belonging to descendants of the Phillips of Setauket. Maps of 1873 show the property belonging to John Trumbull, an Englishman who maintained a blacksmith shop alongside the house. (Courtesy Bellport-Brookhaven Historical Society.)

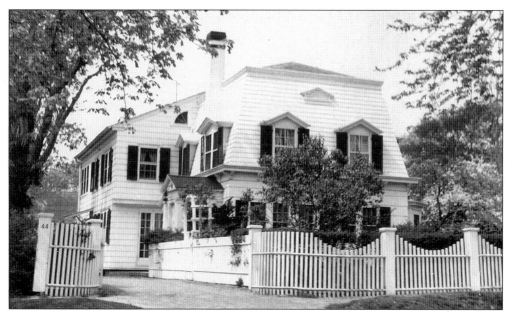

Sitting sideways on its lot, 44 Bellport Lane was built before 1850. After two previous owners, Amanda Rodgers (grandmother of Ira and Ed Rodgers) lived here for about 80 years. Pierman and Armstrong later added the mansard roof for another owner, giving the house a Second Empire look. (Courtesy Bellport-Brookhaven Historical Society.)

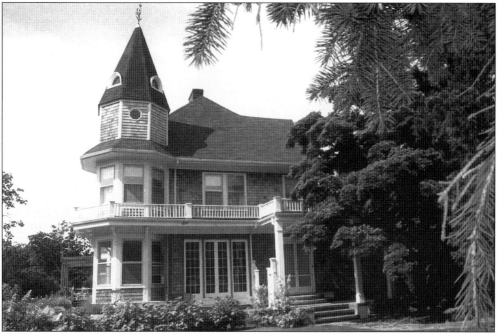

This large Victorian at 42 Bellport Lane has all the hallmarks of the Queen Anne style: an asymmetrical façade with a tower, a steep roof pitch, bay windows, a wraparound second-story porch, and an oriel window. It was built after 1890 and is unusual because it is set far back from the lane. The original clam-shaped shingles have been replaced with plain ones. (Courtesy Robert Duckworth.)

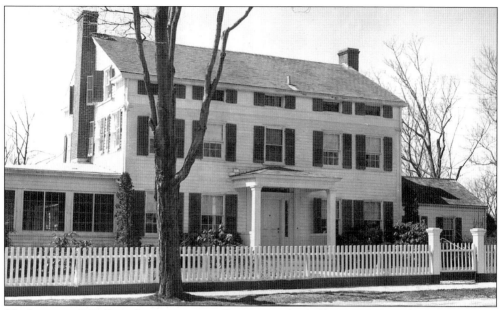

The house at 40 Bellport Lane was originally a one-and-a-half-story structure built before 1850 on property that the Post heirs sold to Robert L. Petty, a highly esteemed local carpenter. It was later raised to add a new and very spacious first floor and remodeled in the Greek Revival vernacular. The distinctive feature of the house is the eyebrow windows set in the full entablature frieze. (Courtesy Bellport-Brookhaven Historical Society.)

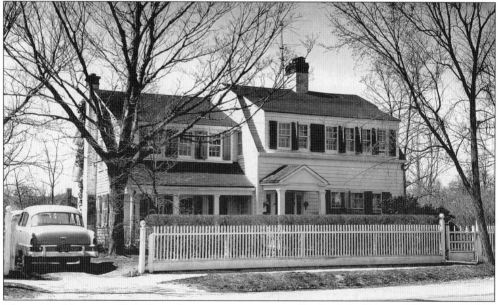

The original house at 38 Bellport Lane was a one-story affair built by Edmund Petty in the late 1840s. It was later enlarged to two stories with a distinctive six-windowed front dormer and a gambrel roof. The south wing is Dutch Colonial in design. The Petty family was one of the oldest in the village. Edmund Petty's wife was a descendant of William Clark, who died on board a British prison ship during the Revolution. The house was once called Big-e-Nuf. (Courtesy Bellport-Brookhaven Historical Society.)

Capt. Dan Petty, brother of Robert Petty, was a master carver of decoys in the mid-19th century. On an 1873 map of Bellport, his family's name appears on two properties on the lane and one on Front Street (Shore Road). Dan Petty was skipper of the *Mary Codder*. (Courtesy Bellport-Brookhaven Historical Society.)

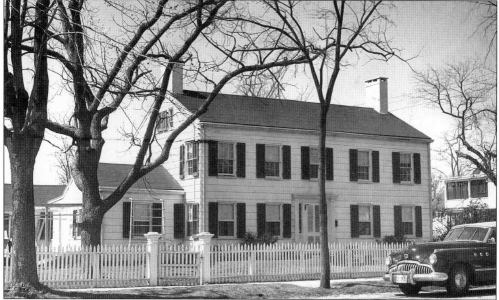

The original part of 36 Bellport Lane was the south side of the main section (three bays long), built *c.* 1839 with a right-sided front entrance. Two north bays were subsequently added by Charles Homan, giving the house a center-hall and Georgian appearance (apparent after an added veranda was later removed). At the same time, the entrance received simple Greek Revival detail on an enlarged surround. The south wing was a separate structure attached to the house later. The old shingles on the house have been stripped of their paint since this picture was taken in 1955. (Courtesy Bellport-Brookhaven Historical Society.)

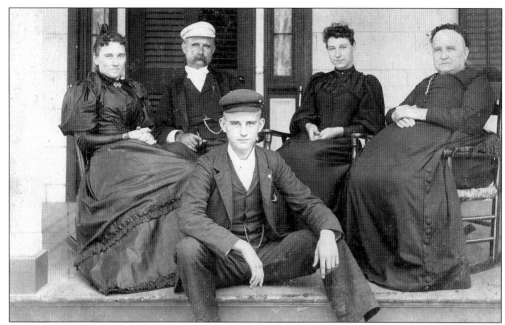

The Nelson Homan family poses on their veranda at 36 Bellport Lane in the 1880s. Many properties on Bellport Lane had verandas or smaller porches facing the lane. Fourth from the left is Mrs. Will Armstrong, and Mrs. Chas Nelson Homan is on the far right. (Courtesy Bellport-Brookhaven Historical Society.)

Set sideways with a south-facing entrance, 34 Bellport Lane was built c. 1858 by Zophar Hawkins Tooker, postmaster in 1879, on the north end of a double-lot property that extends through to Academy Lane. It has been greatly enlarged since. Many properties on the west side of Bellport Lane at this time extended to Academy Lane. Another house once occupied the south lot of the property. It was moved to 6 South Brewster Lane. (Courtesy Bellport-Brookhaven Historical Society.)

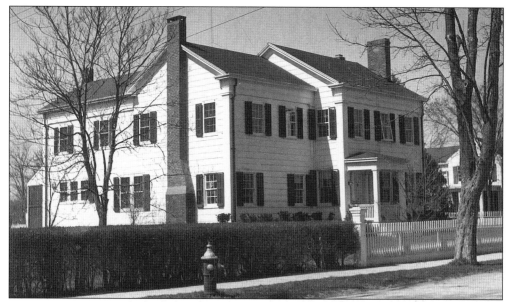

This Greek Revival home at 32 Bellport Lane was built *c.* 1848 by master carpenter Alfred Petty. It is simple and elegant. The south wing was added in 1915 by his granddaughter Belle Petty. Birdsall Otis Edey's grandson Peter Paige lived here with his family from 1952 to 1970. (Courtesy Bellport-Brookhaven Historical Society.)

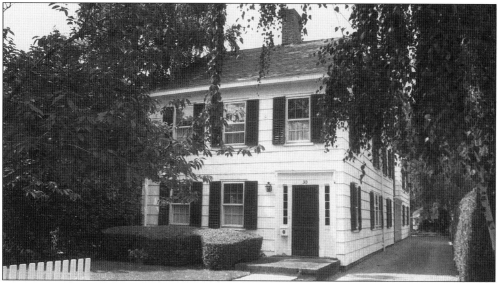

The three-bay, side-hall, center-chimney home at 30 Bellport Lane was built *c.* 1836 by William Raynor of the shipbuilding firm Post and Raynor. The Post and Raynor Shipyard, originally built and owned by the Bell brothers, was located where Osborn Park is today, at the foot of Bellport Lane. The Overton lumberyard and mill later occupied that site. There was also a Post and Raynor store at the southwest corner of Bellport Lane and South Country Road. On an 1873 map, the owner of this property is J.M. Shaw. C.K. Shaw's blacksmith shop (where the hinges for Bellport's fence gates were made until the 1920s) was at the back of this property on Academy Lane. The house stayed in the Shaw family for nearly a century. (Courtesy Robert Duckworth.)

The Post family owned 28 Bellport Lane, with Nathan Post Jr. building the original part c. 1837. Starting in 1911, William Glackens spent five summers here and was frequently visited by his fellow Ashcan School artists. (Courtesy Robert Duckworth.)

Capt. Augustus Gardiner, from one of the oldest families in America (owners of Gardiner's Island), built this jewel of an American house at 24 Bellport Lane c. 1834. The house features subtle Greek Revival details under the eave, around the door, and on the entry porch. Gardiner's daughter, Anne Gardiner Pratt, inherited the house. She was the last person to be buried in the old cemetery on Academy Lane. The new cemetery on Station Road, Woodland, opened after 1876. (Courtesy Robert Duckworth.)

The c. 1876 Italianate house at 22 Bellport Lane was built by Charles Platt for Richard and Dency Gerard. Richard Gerard was appointed postmaster in 1870; contrary to the custom then, he did not run the post office from his home. Instead, he operated it out of the Post and Raynor store (which had been purchased by his brother-in-law in 1858) at the southwest corner of Bellport Lane and South Country Road. In 1915, under a different owner, the house was used as a tearoom. Lou Gerard, Richard's witty son, was village constable and bayman at the turn of the century. (Courtesy Bellport-Brookhaven Historical Society.)

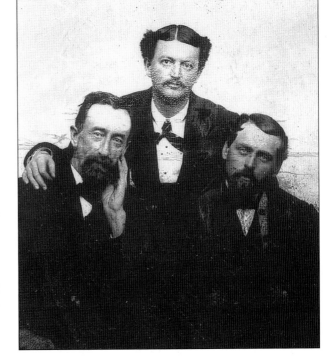

Pictured in this 19th-century photograph are Edwin Post (left) and Richard Gerard (right). Gerard and his wife once owned 22 Bellport Lane. The man in the center is probably Eugene Camerden, who grew up with his sister Mary Willow Camerden in the house at 93 South Country Road. (Courtesy Bellport-Brookhaven Historical Society.)

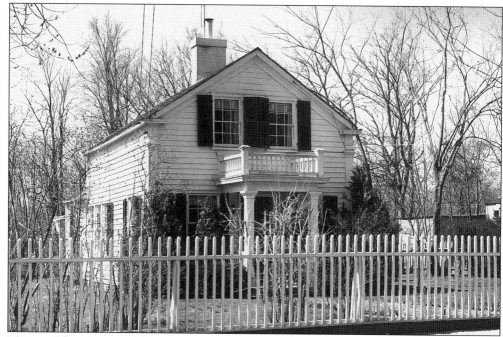

This small Greek Revival house, 18 Bellport Lane, was built in the early 1840s. In 1853, Lyman Smith sold it to Oliver Payne, an African American who lived there until it was purchased in 1860 by Capt. Edward Osborn. It remained in the Osborn family until 1918, being rented to a tailor and to a caretaker of the Edey estate. In 1920, local photographer Frances Toms purchased the house. (Courtesy Bellport-Brookhaven Historical Society.)

This undated photograph shows, from left to right, Charles Emmett Hulse, Fanny Rider Osborn, and Emilie Rider Hulse in a Bellport garden. (Courtesy Bellport-Brookhaven Historical Society.)

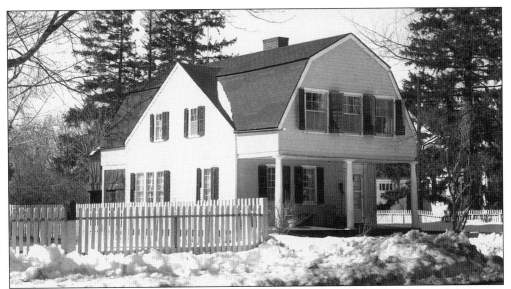

This house, located at 93 South Country Road, is a turn-of-the-century remodeling of a one-and-a-half-story, side-entrance cottage probably built c. 1851. The first known owner of the property was Andrew Homan, followed by Smith Camerden and then by Mary Gardiner. The property was at the western edge of the Edward Osborn estate on the north side of South Country Road. (Courtesy Bellport-Brookhaven Historical Society.)

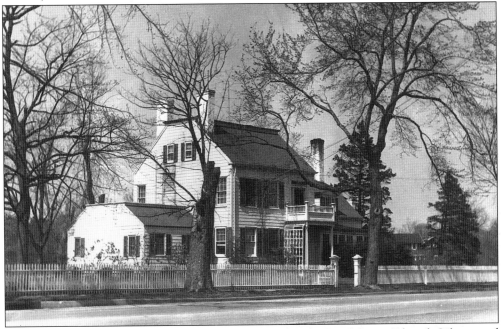

Built in the mid-19th century, this house was the residence of Capt. Edward Osborn and Catherine Gerard Osborn. The property bordered on South Country Road and Station Road, and the house was set west of the corner. Captain Osborn also owned a store (from which he ran a post office) across the street on the southwest corner of Bellport Lane and South Country Road. The house was razed in 1958, and part of the property was developed into a small shopping center. (Courtesy Bellport-Brookhaven Historical Society.)

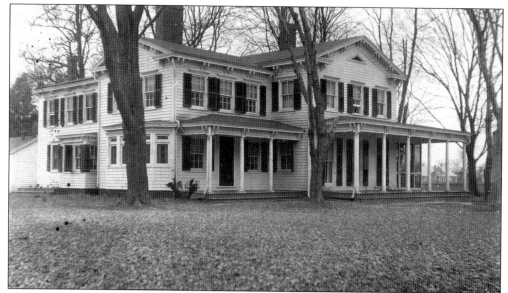

This house was built in the third quarter of the 19th century and was an Osborn family residence until *c.* 1900. It is believed that Catherine Gerard Osborn commissioned this house and occupied it after she was widowed. The house still stands as the Old Inlet Restaurant. (Courtesy Bellport-Brookhaven Historical Society.)

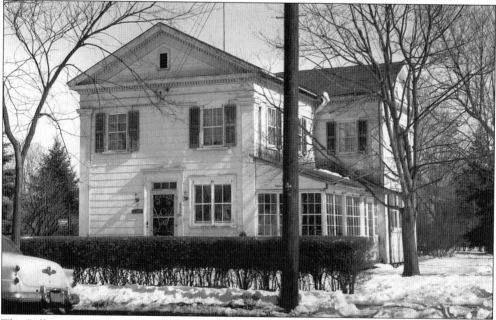

The Bellport Division of Sons of Temperance was, in the mid-19th century, one of the oldest and most successful temperance organizations in Suffolk County. The first floor of this building at 164 South Country Road was used as a place of worship first by the Congregationalists and then by the Methodists. Ironically, a saloon occupied it later, run by John Weidner. Ira Rodgers owned it for many years. Walter Lippmann and Charles Evans Hughes were among the distinguished people who rented it. It is still called Temperance Hall. (Courtesy Bellport-Brookhaven Historical Society.)

The east wing of the building at 191 South Country Road, known as Aldersgate, is most probably the oldest structure standing in Bellport Village. Dating from pre-Revolutionary times, it was built as a cottage for slaves on the plantation of Justice Nathaniel Brewster. Much of the land belonging to the Brewster family was eventually sold to Capt. Thomas Bell. (Courtesy Tom Binnington.)

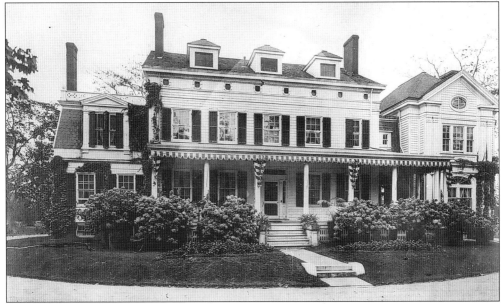

This Greek Revival mansion on South Country Road was built *c.* 1835 by Henry Weeks Titus and became an Otis residence after 1865. It is called Nearthebay. This huge farm spread from South Country Road down to the bay and included a well-known swan pond known as the Peat Hole. The property had a playhouse where Birdsall Otis Edey often sponsored benefit productions. In the mid-20th century, the property was subdivided. The west wing of the mansion, seen in this early photograph on the right, was removed to Titus Lane and is now a private residence. (Courtesy Natalie Paige.)

Birdsall Otis Edey was born Sara Birdsall Otis in 1872 and died in 1940. She was an accomplished poet, the benefactor of the Bellport Memorial Library, a lifelong supporter of the Girl Scouts, and very active in the women's suffrage movement. She was an activist for Bellport as well, fighting to save its fine old trees from street wideners and succeeding in getting the state highway (known as Robinson Boulevard and, later, as the Montauk Highway) to bypass Bellport by half a mile to the north. Although she had homes elsewhere and traveled all over the world, the place she considered her real home was Bellport, which she described as "this blessed corner of the earth where I belong." (Courtesy Natalie Paige.)

Pictured is the fire that destroyed the Nearthebay Playhouse in 1971. In the early 20th century, Birdsall Otis Edey had sponsored several productions at the playhouse to benefit the Bellport Memorial Library. (Courtesy Emily Czaja.)

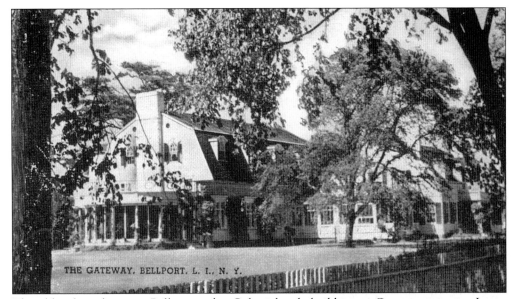

THE GATEWAY, BELLPORT, L. I., N. Y.

The oldest large house in Bellport is this Colonial-style building on Gateway property. It was built in 1827 for Charles Osborn and was purchased in 1884 by Mr. and Mrs. J.L.B. Mott as a summer residence. The Motts called their home Brook Farm and hired Stanford White to construct a new wing that contained a fabulous ballroom. Unfortunately, the wing burned down in 1962. This 1950s postcard shows the gambrel-roofed Stanford White wing of the house. (Courtesy the Allen family.)

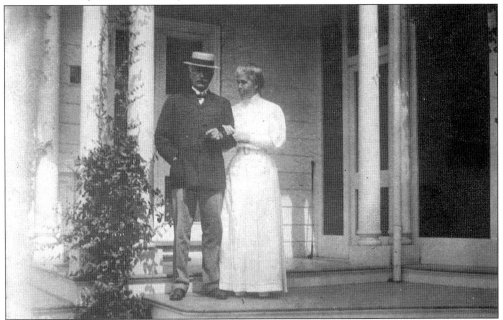

This c. 1900 image shows the Motts standing at the rear side of the porch off the Stanford White wing. The Motts were very philanthropic. After World War I, Mrs. Mott invited disabled veterans to spend summers in a cottage on her property. She also donated the land on which the Bellport Memorial Library stands and financed half the cost of the Bellport community building in 1925. (Courtesy the Allen family.)

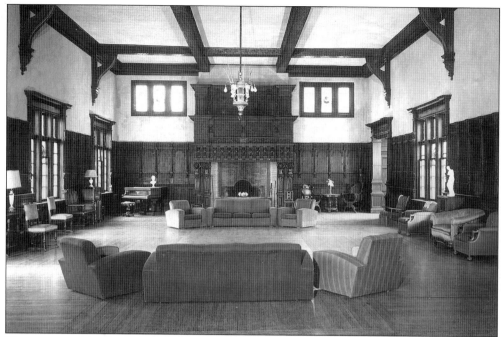

The interior of the Stanford White wing is shown in the 1940s, when the Pomerans owned the property and ran a Christian Science hotel there. It was not until the early 1950s that the Gateway began to be identified as a place for theater. (Courtesy the Allen family.)

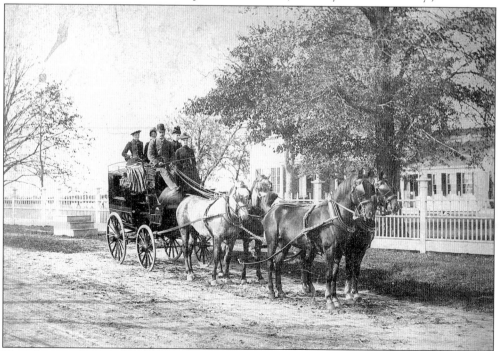

This photograph from the early 1880s shows Mr. and Mrs. J.L.B. Mott in their carriage in front of their home. Mr. Mott is at the reins, and Mrs. Mott can be seen sitting behind him to the right. (Courtesy the Allen family.)

This postcard shows a little girl sitting on the small bridge over Mott's Brook, the eastern boundary of Bellport. It was called Mott's Brook because it lay on the Mott property, Brook Farm. Originally known as Dayton Brook, it was Osborn's Brook when Charles Osborn owned the land. Farther south, about 500 feet from South Country Road, the brook flowed into Col. William H. Langley's estate, Old Kentuck, and was called Langley's Creek. (Courtesy Bellport-Brookhaven Historical Society.)

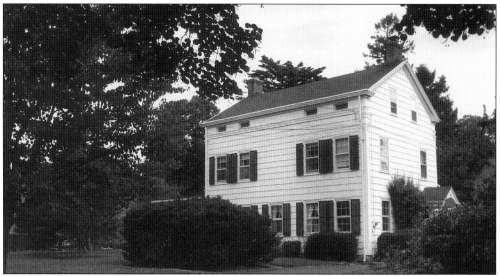

The home of Oliver Hazard Perry Robinson was moved to 33 Browns Lane c. 1918 from where it originally stood on South Country Road. A marker was placed on South Country Road by the Bellport-Brookhaven Historical Society to designate the location of the Robinson home, where the ball bearing was invented. It was built as a one-and-a-half-story house c. 1843 and was used as a post office when Robinson was appointed postmaster in 1861. Bell Port became Bellport under his tenure as postmaster. Browns Lane was named after Robinson's father-in-law, George Brown. At the turn of the century, internationally known illustrator May Wilson Preston lived in the house. (Courtesy Robert Duckworth.)

Built in the 1880s, the house at 49 Browns Lane (originally much plainer than pictured here) was named the Teabox by the Goldthwaites because of its boxy shape. They took in summer boarders here before opening their well-loved inn across the street, the Goldthwaite. (Courtesy Robert Duckworth.)

This building, at 4 Browns Lane, was moved here in 1873 from the corner of Browns Lane and South Country Road. It was a parsonage of the former Presbyterian church (now Methodist) on South Country Road opposite Browns Lane. Browns Lane was once known as Rector Street for this parsonage, or rectory. It was originally a one-and-a-half-story cape that was drastically remodeled in 1935 by the Marvin family, who had purchased it in 1922. (Courtesy Bellport-Brookhaven Historical Society.)

This distinctive house, at 27 Browns Lane, was built in the late 1880s and was once the home of Everitt Price, a butcher by trade and Bellport's first mayor and first fire chief. The house was moved farther south from its original location on Browns Lane c. 1900. The house is an exuberant Gothic-influenced Folk Victorian, displaying fabulous sunburst carvings at the overhanging gables. (Courtesy Robert Duckworth.)

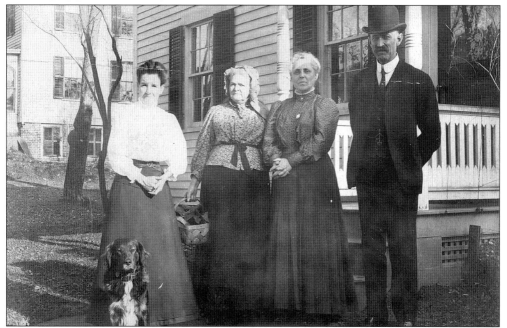

Bellporters pose for a picture c. 1910. From left to right are Emma Allison, Martha Gerard Bell, Hildah Shaw, and Henry W.T. Post. Martha Bell was married to Joseph Henry Bell, son of Jacob Bell and his second wife, Rebecca Rider. Jacob was the father of the founding Bells. (Courtesy Bellport-Brookhaven Historical Society.)

The three-bay, side-gabled house at 14 Academy Lane was built *c.* 1858 and was at one time owned by Henry Kreamer Sr., whose son Henry Jr. was a captain at the Bellport Life Saving Station. Another son, William, ran Taffy Point, then the Bell Inn, and finally the Wyandotte. The house was sold out of the Kreamer family *c.* 1890. It is no longer painted white, as this 1955 photograph depicts, but is now grey shingled. (Courtesy Bellport-Brookhaven Historical Society.)

The house at 7 Hulse Street was built by Robert Petty *c.* 1837. It was purchased by Capt. Ebenezer Hulse in 1852. It was then passed on to his daughter Sarah Piermann and then to George Hulse Piermann of the firm Armstrong and Piermann. George Piermann added the continuous dormer across the front, an architectural solution that was used on some other buildings in the immediate area. (Courtesy Bellport-Brookhaven Historical Society.)

This photograph shows Will Armstrong of the firm Armstrong and Pierman at work in the barn that the firm occupied for many years near Bellport Lane. The barn later became the Bellport-Brookhaven Historical Society's Barn Museum after it was moved across Bell Street to the Post-Crowell property. Will Armstrong and George Pierman were responsible for enlarging and modernizing many old Bellport homes. (Courtesy Bellport-Brookhaven Historical Society.)

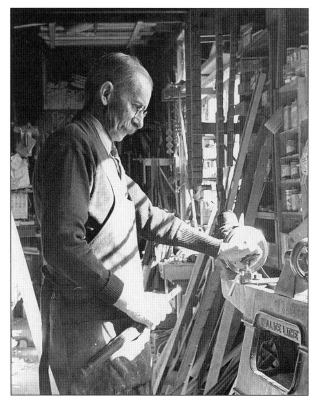

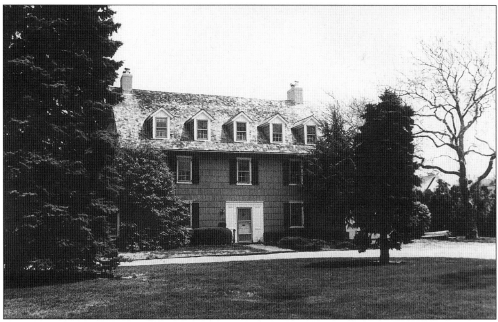

This Georgian Colonial home was built in Amityville by the Carman family c. 1770 and was floated to Bellport in 1928. It is located on Bayberry Road and was owned for many years by the Pelletreau family. The dormers were added in 1930. It is now a designated historical landmark. (Courtesy Robert Duckworth.)

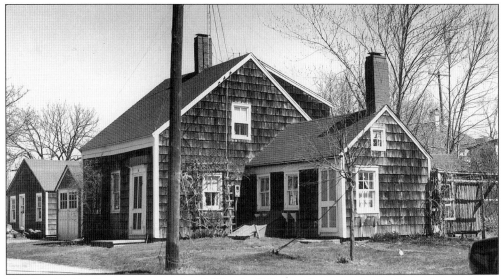

The Eva Smith House once stood at 9 Woodruff Street. A one-and-a-half-story house, it was typical of the 18th- and early-19th-century vernacular for New England and eastern Long Island. It was important because it was the only one of its kind extant within the confines of the village. This half Cape Cod–style house was built by Matthew Edmund Woodruff and was moved before 1900 slightly north of its original location on South Country Road. It was sold to the Smiths by the Hulse family. Sadly, the house and three other old structures adjacent were torn down in 1989 for a parking lot, and the little Woodruff Street neighborhood was changed forever. (Courtesy Bellport-Brookhaven Historical Society.)

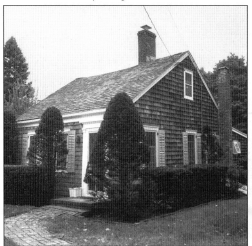 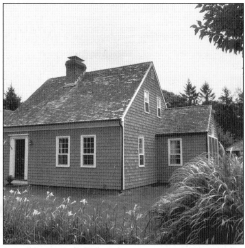

Left: Another half Cape Cod–style house native to the area and in its original location stands just east of the village at 234 South Country Road. Predating the large Cook estate that existed *c.* 1900 off Bellhaven Road by about 100 years, it housed the estate's caretaker, Ellsworth Rogers. Writer Mary Roberts Rinehart spent the summer of 1918 at the Cooks' property. (Courtesy Robert Duckworth.) *Right:* Hidden away on a cul-de-sac off Gerard Street is still another half Cape home, to which another center-chimney house of the same vintage has been attached. This home is not original to Bellport but was built in Peconic in the 17th century on the North Fork of Long Island. It was moved here in the 1970s by the Brown family and is now a designated historic landmark. (Courtesy Robert Duckworth.)

Six

CHURCHES
AND SCHOOLS

*It is a new and strange day which the old meeting-house that for so long stood
across from the "goin' over" at the Carman's River is witnessing. . . .
Though transplanted, the church still reveals a dignity and beauty that
since 1828 inspired and spoke truths which never die.*

—George Borthwick
From *The Church at the South: A History of the South Haven Church*

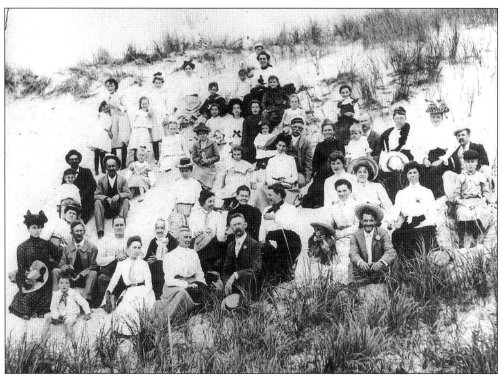

In the summer of 1903, members of the Methodist and Episcopalian churches had a picnic on
Fire Island. Known to be in this photograph are Anne McKeown, Leverett Brown, Ida Brown,
Louis Manzie, Bella Rodgers, Janet Curran, Mary Reeves, Addison Bumstead, Rosalind Miller,
Jennie Newey, John Seaman, Mrs. Forrest Reeves, Vernon Hawkins, and Alice Hawkins.
(Courtesy Bellport-Brookhaven Historical Society.)

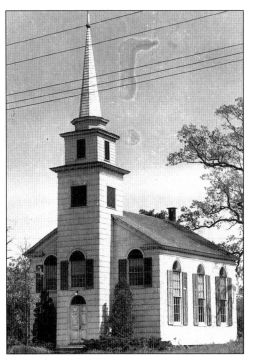

The Old South Haven Presbyterian Church of Brookhaven was built c. 1828. It originally stood at the site of an earlier church, built c. 1740 in South Haven near the Carmans River. The earlier church was known as the church "at the south," and its first pastor was Abner Reeve, whose famous son, Tappan, was the founder of the first law school in the United States, in Litchfield, Connecticut. A famous story associated with the church is that Daniel Webster attended services there while visiting the area but left the service early to catch a large trout that was spotted in the Carmans River. His catch was commemorated with a trout weathervane placed on the steeple and, later, with a print by Currier and Ives. (The weathervane on the steeple today is a reproduction.) In 1961, the church was moved to its present location at the corner of South Country Road and Beaver Dam Road. (Courtesy Bellport-Brookhaven Historical Society.)

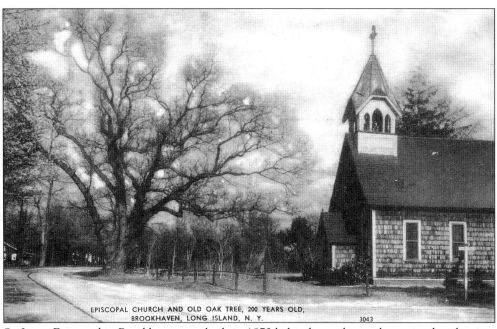

St. James Episcopal in Brookhaven was built in 1872 behind an oak tree that existed at the time of the American Revolution near Beaver Dam Road. The original Gothic bell tower was destroyed in a hurricane and replaced in 1961 with the current, plainer bell tower. The ancient oak tree died at the end of the 20th century. (Courtesy Bellport-Brookhaven Historical Society.)

The Ruth African Methodist Episcopal Zion Church on Station Road is the oldest church in Bellport. The building, formerly a modest home, dates from 1827 and was moved twice. It has been in its present location since 1926, when it was enlarged under the supervision of Rev. T. Edwards. Before the Civil War, this church was alleged to be a link in the Underground Railroad for slaves escaping to Canada. The building and land were deeded to the church by Charles Osborn and revert to the Osborn family if it ever ceases to be used as a church. (Courtesy Robert Duckworth.)

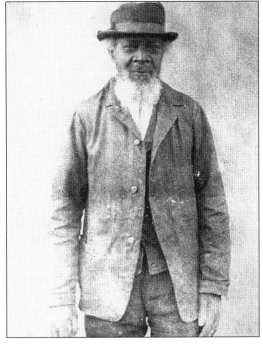

This rare photograph shows Rev. Dea. Charles Carle, founder of the African Methodist Episcopal Church of Bellport, the earlier name of the church, in 1838. Carle worked for Charles Osborn and his son Henry Osborn. Oral tradition has it that a young Charles Carle was owned by one of the Bell brothers, who gave him his freedom that allowed him to work as a freeman and found his church. Slavery did not officially end in New York State until 1833. (Courtesy Bellport-Brookhaven Historical Society.)

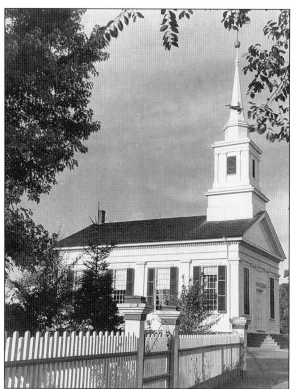

The Methodist church in Bellport occupies this building, constructed in 1850 by the Congregationalists and Presbyterians on land deeded to the church by the widow of Charles Osborn. It is one of the most beautiful and architecturally important structures in the village, considered unequivocally the best surviving example of Greek Revival country church architecture in Sufffolk County. The singular serenity of the church was compromised in 2001 by an addition that crowds its setting. (Courtesy Prisilla Carleton.)

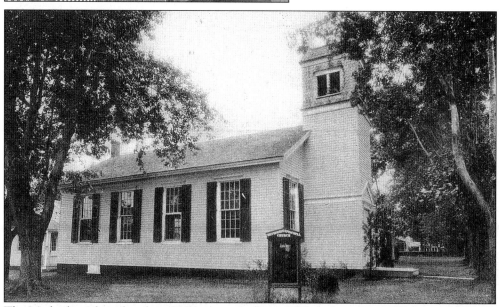

The Methodists' first church in Bellport was built in 1873 at the corner of Rector and Maple Streets, now Browns Lane and Maple Street. In 1945—when the congregation outgrew that structure and acquired its present church from the Presbyterians by exchanging its first church in Brookhaven for it—the congregation sold the Rector Street church building to a Methodist group in Massapequa Park, floating it there via the bay. (Courtesy Bellport-Brookhaven Historical Society.)

The first Brookhaven Methodist Church, now a private residence, was built in 1848 without a steeple on the opposite side of the road where it is now located. This rare photograph shows what the church looked like before it was moved in 1872, when the steeple was added. The building became a Presbyterian property in the 1945 exchange. (Courtesy Bellport-Brookhaven Historical Society.)

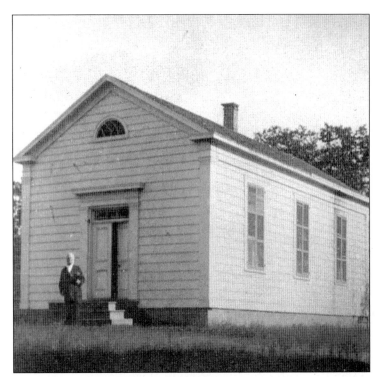

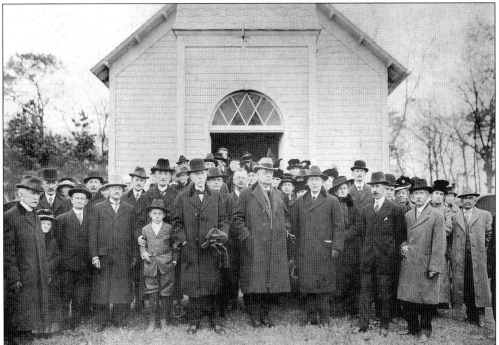

This 1917 photograph of the congregation of the Brookhaven Methodist Church shows the church at its present site with the added steeple. The three men in front center are, from left to right, Rev. Dr. Barton, Dr. Kavanaugh, and Dr. Wilson. (Courtesy Bellport-Brookhaven Historical Society.)

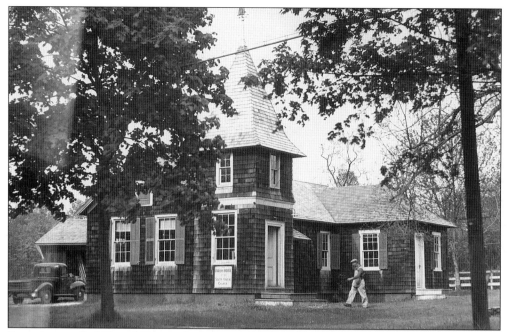

Sometimes called Chapel House, the Lecture Room of Fire Place was built *c*. 1845. It was a tiny Congregational church that before the turn of the century was deeded to the South Haven Presbyterian Church and moved across South Country Road, where it now stands, opposite from its original location. A steeple was added when it was enlarged in its new location. It was used as a parish house for church suppers and also as an amateur playhouse. The Presbyterians sold it in 1945 to George Perley Morse, who used it as an antiques shop. It is now a private residence. This picture dates from the 1930s. (Courtesy Brookhaven Free Library.)

Christ Episcopal Church in Bellport was built in 1896 on land donated by Potter and Price, who were responsible for the development of Howell's Point Road. Village resident Charles A. Rich, who designed Sagamore Hill, was its architect. The postcard dates from *c*. 1910. (Courtesy Bellport-Brookhaven Historical Society.)

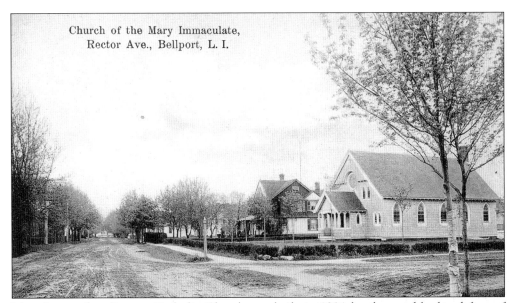

Church of the Mary Immaculate, Rector Ave., Bellport, L. I.

Mary Immaculate Roman Catholic Church was built in 1904 by the neighborhood firm of Robinson and Watkins. The architect was Isaac Green. The small country church, originally shingled, was erected on land purchased with the financial help of two cooks, Catherine Ferguson and Catherine Howard, who worked for Mr. and Mrs. J.L.B. Mott. This delightful little church is a far cry from the auditorium annex that was built next door in 1953. (Courtesy Bellport-Brookhaven Historical Society.)

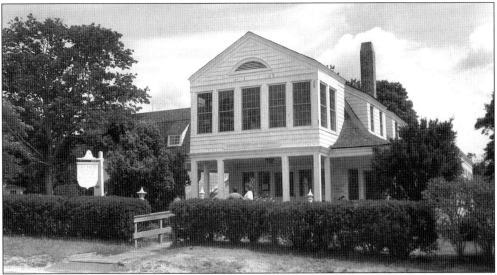

The Unitarian Universalist Fellowship of Bellport has occupied the building at 51 Browns Lane since 1962, a year after the American Unitarian Association merged with the Universalist Church. The first documented owner of the land was Joseph Marvin. In 1887, a Mrs. William Smith constructed a cottage on the property. The property was later sold to W.T. Walton and then to Charles E. Bedford. Dorothy Ivison purchased the property in 1941, and it was sold to Helen Carll in 1960. Each owner enlarged or remodeled the building, with Bedford adding the north wing. The house is Dutch Colonial in design, with its gambrel roof interrupted by an added front-gable overhang facing Browns Lane. (Courtesy Robert Duckworth.)

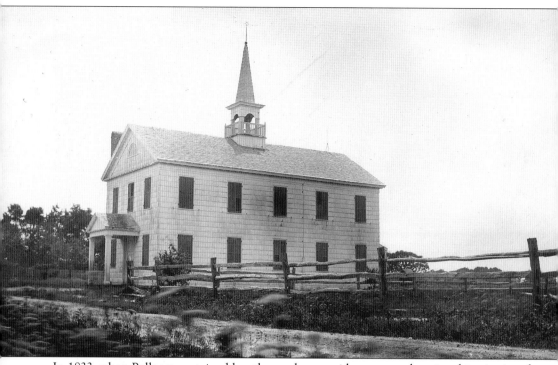

In 1833, when Bellport contained less than a dozen residences, an educational institution that was also used for Congregationalist meetings was built. The building was called the Bellport Classical Institute (also known as the Academy) and was erected by Clark Homan and Samuel Brown of Bellport, Isaac Hudson of Middle Island, and the Aldrich brothers of Patchogue. It originally stood on the west side of Academy Lane (which was then called School Street and, later, Osborn Lane) opposite the little perpendicular street then called Academy Lane (now Osborn Street). Students came from Bellport and beyond, with those from other towns boarding at Bell House. At first it was a private school offering only a secondary education. Later, it became public and the grade school was added. When the Union Free School District was organized in 1901, a new schoolhouse was built on Railroad Avenue (now Station Road), and the academy became obsolete. It was sold and moved to the east side of the street near where Shaw's blacksmith shop once stood. George Carman used it as a carpentry shop. Later, it was sold to contractors Armstrong and Piermann and, in 1919, to a Dr. and Mrs. Lloyd, who moved it back to the west side of Academy Lane and south toward the bay. The Lloyds had it remodeled into a home under the supervision of Walter Granville Smith. The photograph shows the academy building as it originally looked, at its original location north of the old cemetery. (Courtesy Natalie Paige.)

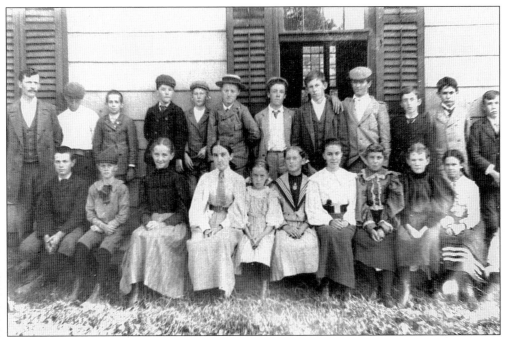

This class photograph was taken *c.* 1896 outside the Bellport Classical Institute. The teacher, at the extreme left, is Fletcher Walling. (Courtesy Bellport-Brookhaven Historical Society.)

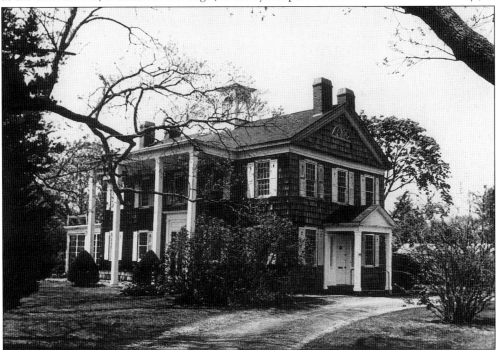

The Bellport Classical Institute, a designated historical landmark, is shown as it appears today. The north wing, back porch, and side colonnade are additions. The belfry is original, but the steeple on top of it was removed, as was the low balustrade surrounding the belfry. (Courtesy Robert Duckworth.)

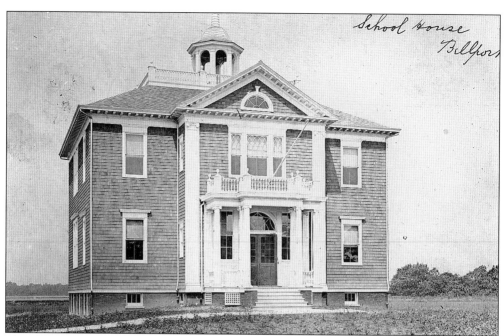

The distinctive building pictured above was Bellport's first public school c. 1904 after the Union Free School District was organized. It was located on Station Road and had only lower grades. In 1929, after the construction of the modern school, pictured below, it was no longer used. The 1929 building burned in 1963. (Above and below courtesy Bellport-Brookhaven Historical Society.)

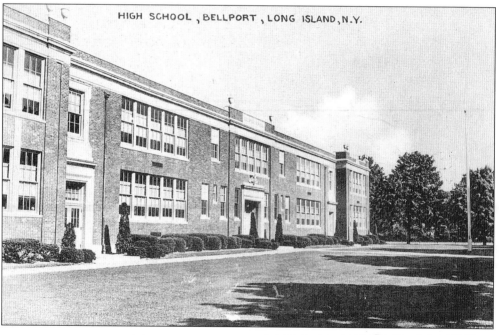

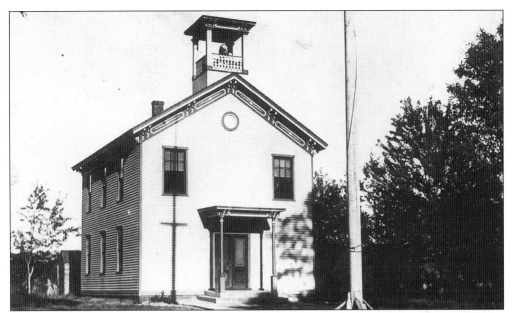

Brookhaven Hamlet had its first school in 1802 in a tiny building on Fire Place Neck Road. Later, a second school was constructed on the same road but was soon outgrown. In 1873, this school was built. It temporarily housed the Brookhaven Free Library after a new school was constructed in 1927. It was later floated to Bellport and used as part of a home. (Courtesy Post-Morrow Foundation.)

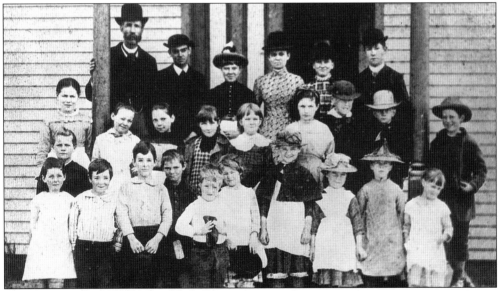

This class photograph dates from c. 1886 and was taken in front of the school. From left to right in the back row are ? Adriance (principal), George Miller, Lottie Brown, ? McInirk, Ethel Reeves, and Bert Adriance. The children are, in alphabetical order, Charlie Adriance, Ernest Barteau, Clara Brown, Hattie Brown, Sam Bumstead, Bertha Cleaves, Lelard Cleaves, Ruppert Cleaves, Ella Darling, Elizabeth Hawkins, Ella Hawkins, Sherman Hawkins, Ella Kearney, Katie Kearney, Louise McAllister, Cora Murdock, Florence Smith, Nina Smith, and Celia Swezey. (Courtesy Bellport-Brookhaven Historical Society.)

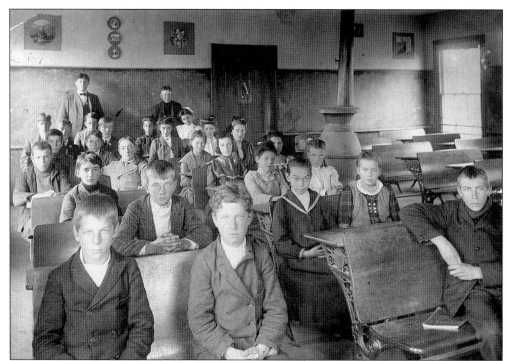

This photograph was taken on the second floor of the Brookhaven School *c.* 1900. In the first row are, from left to right, Harry Murdock, Gerard Esperson, and Morris Hawkins. In the second row are, from left to right, Clinton Smith, Beatrice Swezey, and Eva Newey. Their teacher, standing in the rear, is Mr. Walker. (Courtesy Bellport-Brookhaven Historical Society.)

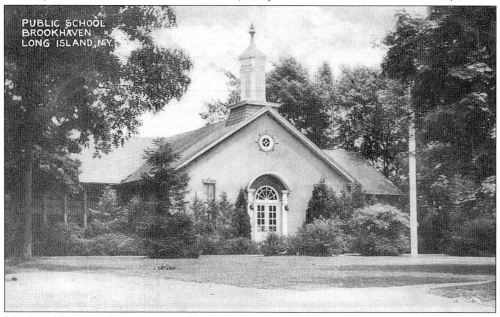

The Brookhaven Public School building of 1927, shown here, replaced the 1873 schoolhouse. The building is just south of the modern school on Fire Place Neck Road. The striking cupola was restored in 2000. (Courtesy Post-Morrow Foundation.)

Seven

THE BROOKHAVEN
HAMLET SCENE

*It is only a short walk from Bellport to Brookhaven; three or four miles at the most,
I should say. You turn to the right when a wooden church comes into view,
and here you strike real country roads, and are much more apt to encounter
carts and wagons than hurrying motors. For Brookhaven is just what its name implies,
a quiet little village where one would have time for contemplation, where there isn't
the slightest pretense or desire for it; a tiny side room, as it were; a pleasant
place to take a nap, to write a letter, or to read a book.*

—Charles Hanson Towne
From *Loafing Down Long Island* (1921)

In this *c.* 1900 postcard of Beaver Dam Road, we can see St. James Episcopal Church in the distance with its original Gothic bell tower. On the left is the home of Nehemiah Hulse, a one-and-a-half-story Cape Cod house that is hardly recognizable today. (Courtesy Bellport-Brookhaven Historical Society.)

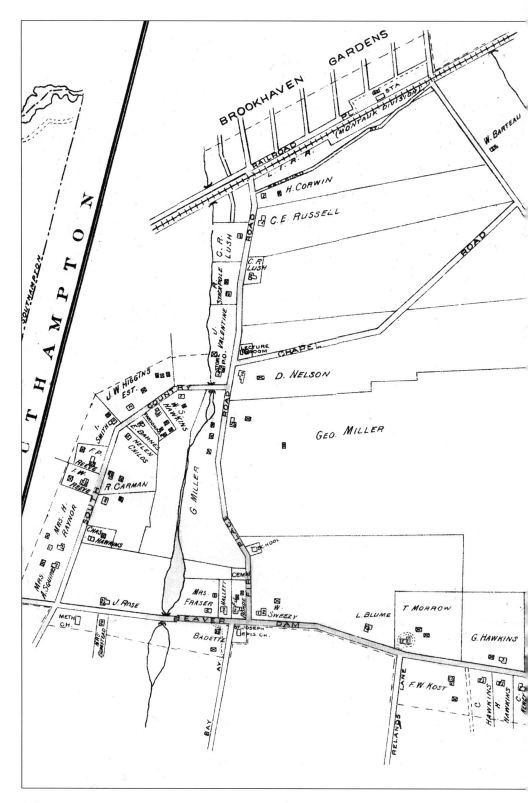

108

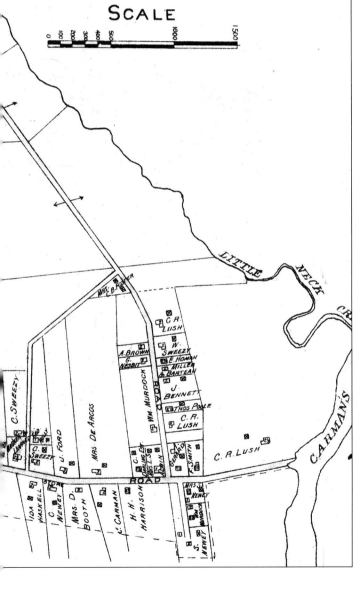

BROOKHAVEN

SCALE

This 1915 map of Brookhaven Hamlet shows the names of the streets as they are today. South Country Road, originally called the Highway at South, was established in 1702 and connected the hamlet with Bellport. Beaver Dam Road was completed by 1735 as South Street. Fire Place Neck Road was once called Beaver Street, and Bay Road was a farm road called Atlantic Street in 1873. The yet-to-be-named Locust Road was also a farm, or cart, road. The first Methodist church is shown, but the Presbyterian church is not because it was still in South Haven. The largest farm belongs to the George Miller family. Arthur Danto, an eminent philosopher and resident of Brookhaven, described the hamlet in 1985 as follows: "The community is an intersection of distinct but harmonizing cultures: it is agricultural without being a farming community; there is a life of the bay without its being a fishing village; there is a population of scientists from the Brookhaven Laboratories without it being an intellectual enclave; there are artist and writers without its being an artists colony. Nor is it a dormitory town or a resort. It is a unified society precious for its variousness." (Courtesy Norman Nelson.)

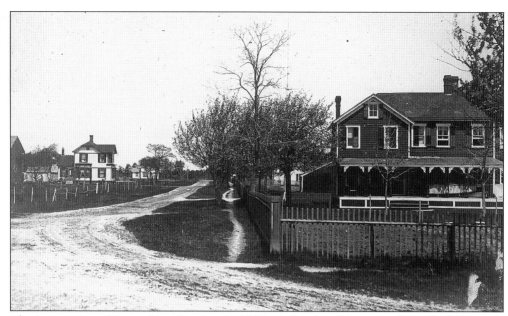

The intersection of Beaver Dam Road and Old Stump Road in this postcard view looking north c. 1905. The house on the right is gone, but the white house on the left still stands. Old Stump Road was once called Railroad Avenue because it led to the Brookhaven Hamlet train station. Both Bellport and Brookhaven were connected with the Montauk branch of the Long Island Rail Road after it opened in 1881. Before that, the villages relied on the Greenport line that opened farther north in 1844. (Courtesy Bellport-Brookhaven Historical Society.)

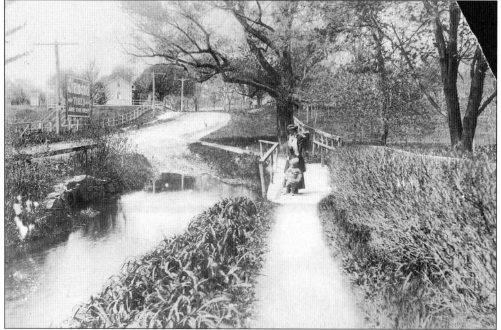

This c. 1912 photograph, looking west just past the intersection of South Country Road and Fire Place Neck Road, shows Valentine's Brook. Today it is called Beaver Dam Creek. (Courtesy Post-Morrow Foundation.)

Salt hay was an important commodity in the 17th century and was one of the reasons the settlers were attracted to this area. Painter Fredrick Kost, who owned the old Deacon Hawkins House in Brookhaven Hamlet, documented the gathering of salt hay in photographs in the early 20th century. This photograph shows Wallace Swezey loading salt meadow hay, or kelp, onto a wagon after a harvest. (Courtesy South Country Library.)

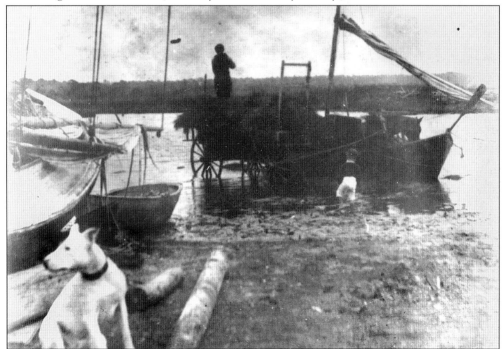

Another Kost photograph on the subject of salt hay features the artist's dog Murphy. (Courtesy Brookhaven Free Library.)

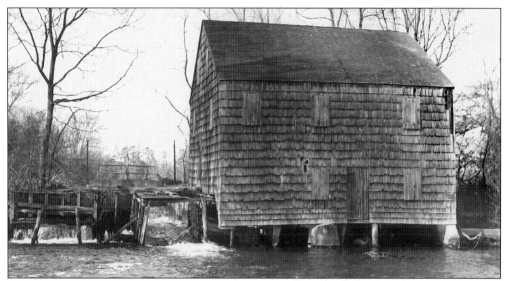

This 18th-century structure was the South Haven Grist, Saw, and Fulling Mill. At that time, there were three mills on the Connecticut (Carmans) River. One was north of Yaphank, one at Yaphank, and this one in South Haven, which seems to have been the most prosperous. It had various owners, among them the Homan family before the Revolution and the Carman family after. The mill was in operation into the early 20th century. It was demolished in 1958 because it was in the way of the Sunrise Highway. (Courtesy Bellport-Brookhaven Historical Society.)

This late-18th-century house was built by the Carman family when they owned the mill. It stood opposite the South Haven Presbyterian Church near the mill. The Carmans were prosperous. Besides the mill, they also operated from their homestead a tavern, post office, and provided banking services. Boats could come through the inlet and up the Connecticut (Carmans) River and dock near the Carman establishment. The homestead was torn apart in 1936, when the purchaser established a duck farm on the land and used parts of the old Carman homestead to build duck houses. (Courtesy Bellport-Brookhaven Historical Society.)

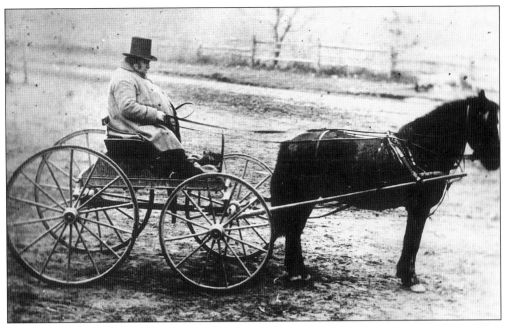

"Big Tom" Ellison, born in 1806, was the son of the first postmaster of Fire Place. He and his mother ran a store and tavern at the original location of the Brook Store, which is opposite from where it now stands. Ellison was evidently a character. In the 1850s, he became town trustee. (Courtesy Bellport-Brookhaven Historical Society.)

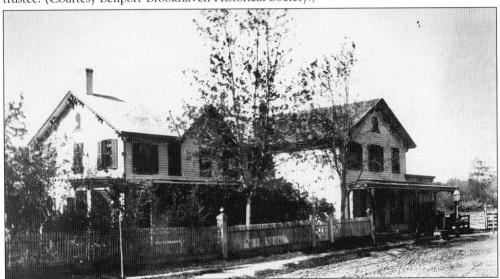

The original store operated by Big Tom Ellison and his mother was purchased c. 1860 by Hallack Bishop, who razed the buildings and built a new store (right) and home (left) after 1872. These were later purchased by Charles Valentine, who together with Forrest Reeves, ran the business, which included a post office. The area soon became known as Valentine's Corner, and the brook became Valentine's Brook. The property remained in the Valentine family until 1916, when a Dr. Noble purchased it. Noble moved the house to 3 Fire Place Neck Road (opposite the triangle) and the store to the opposite side of South Country Road, where it is known today as the Brook Store. (Bellport-Brookhaven Historical Society.)

This photograph of the interior of the Brook Store c. 1898 shows Forrest Reeves standing at the far left and John Valentine standing on the right. Sitting, from left to right, are William Nesbitt, Ed Ketcham, Tom Swezey, N.C. Miller, Sid Hawkins, and George Miller. (Courtesy Brookhaven Free Library.)

This photograph shows children enjoying Valentine's Brook c. 1910. The brook was a place of scenic beauty and quiet pleasure. There are many postcards from this period that depict the tranquil pleasures of the brook. (Courtesy Post-Morrow Foundation.)

Beaver Dam Road (known as Old Neck Road at the time) is shown in the late 19th century. Barely visible behind the picket fence is the house that was once the home of William Brewster Rose, the grandson of Jesse Rose, who lived just west of this spot on the same side of the road. (Courtesy Bellport-Brookhaven Historical Society.)

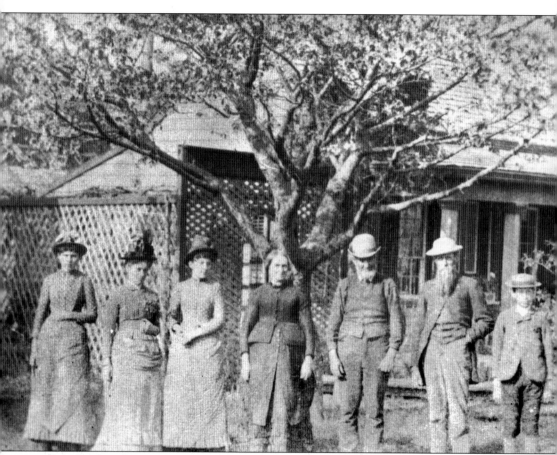

This photograph was taken in the latter half of the 19th century on the grounds of the William Brewster Rose home, at 339 Beaver Dam Road. The view shows the last generation of the Rose family of Brookhaven Hamlet with their friends. From left to right are Grace Barteau, Lizzie Bennett, Mamie Barteau, Parnel Reeve Rose, William Brewster Rose, John Rose, and William Rose. The veranda on the house was gone by the early 20th century. (Courtesy Bellport-Brookhaven Historical Society.)

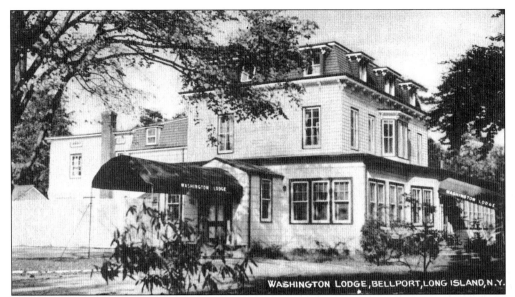

The large mansard-roofed house at 287 South Country Road was built *c.* 1848. Between 1915 to 1925, it was the summer home of the man who invented instant coffee. Emigrating from Belgium and adopting the name George Washington, he marketed his instant coffee as G. Washington Coffee. Washington was also interested in horticulture and exotic animals and kept a small zoo at his estate. When he was seen in public, he would often have an exotic bird or monkey on his shoulder. At the time this postcard was printed in the late 1940s, the house had become a restaurant named the Washington Lodge. In 1970, a small school was started there called the Bay Community School, which closed in 1983. Today, it is summer house for the Marist Brothers, a Roman Catholic order. (Courtesy Bellport-Brookhaven Historical Society.)

Brookhaven Hamlet had several boardinghouses in the early 20th century. The best known was the Edgewater Inn (pictured here), operated by Rachel D'Arcas. The house, originally a Rose family home built *c.* 1820, stood on the north side of Beaver Dam Road near Squassux Landing. It burned down in 1930. (Courtesy Bellport-Brookhaven Historical Society.)

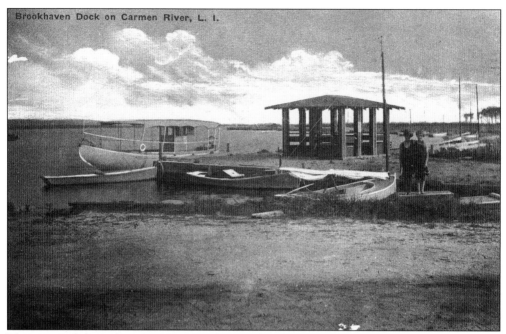

This postcard shows how Squassux Landing appeared *c.* 1925. (Courtesy Bellport-Brookhaven Historical Society.)

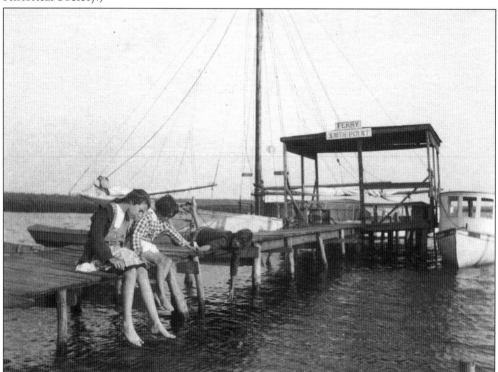

This postcard shows the ferry dock at Squassux Landing *c.* 1914. Brookhaven Hamlet had ferry service to Smith Point for a few years. Sometimes, the Old Inlet ferries, the *Ruth* or the *Mildred A.*, would provide service from Squassux Landing to Smith Point as well.

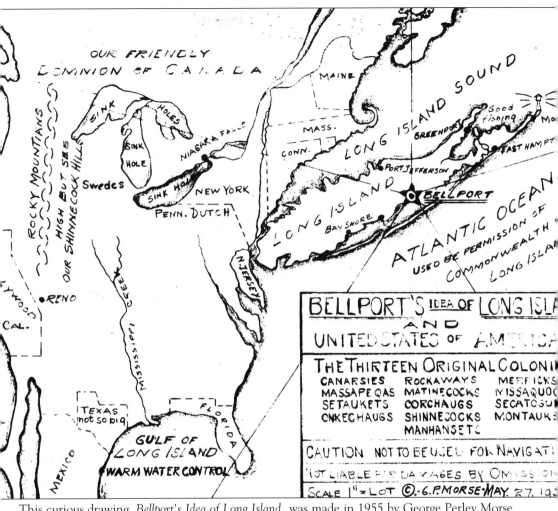

Inside the map:

OUR FRIENDLY DOMINION OF CANADA

MAINE

SINK HOLES

SINK HOLE

NIAGARA FALLS

MASS.

CONN.

LONG ISLAND SOUND

GREENPORT

Good Fishing

EAST HAMPTON

Mo

ROCKY MOUNTAINS

HIGH BUT SEE OUR SHINNECOCK HILLS

Swedes

SINK HOLE

NEW YORK

PENN. DUTCH

NEW YORK

PORT JEFFERSON

BELLPORT

BAYSHORE

LONG ISLAND

ATLANTIC OCEAN

USED BY PERMISSION OF COMMONWEALTH OF LONG ISLAND

N. JERSEY

RENO

CAL.

MISSISSIPPI CREEK

TEXAS not so big

FLORIDA

GULF OF LONG ISLAND

WARM WATER CONTROL

MEXICO

BELLPORT'S IDEA OF LONG ISLA[ND]
AND
UNITED STATES OF AMERICA

THE THIRTEEN ORIGINAL COLONI[ES]

CANARSIES	ROCKAWAYS	MERRICKS
MASSAPEQAS	MATINECOCKS	NISSAQUO[GUES]
SETAUKETS	CORCHAUGS	SECATOGU[ES]
ONKECHAUGS	SHINNECOCKS	MONTAUKS
	MANHANSETS	

CAUTION NOT TO BE USED FOR NAVIGATI[ON]

NOT LIABLE FOR DAMAGES BY OMISSION

SCALE 1" = LOT ©.- G. P. MORSE·MAY. 27. 19[55]

This curious drawing, *Bellport's Idea of Long Island*, was made in 1955 by George Perley Morse and recalls Saul Steinberg's famous cover for the *New Yorker* magazine. Morse retired to Brookhaven Hamlet at age 38 after a successful career as an engineering consultant and previously earning the Navy Cross in World War I. He was devoted to the hamlet, interested in its history, and collected material and photographs on historic homes and places, creating a two-volume work on the subject. As president of the Brookhaven Village Association, he was instrumental in the attempt to establish a historical society there. He played a part in the association's establishment of Squassux Landing when the property was given to Brookhaven Hamlet by the Post family. For a number of years, he and his wife operated an antiques business from the old Presbyterian Lecture Room. A fascinating tidbit is that Morse was also responsible for carving an eagle's body and adding it to an old eagle's head he owned. The complete bird was later loaned to the Bellport-Brookhaven Historical Society by his family and is on permanent display in the Brown Building on the museum's grounds. (Courtesy Bellport-Brookhaven Historical Society.)

The Fire Place Literary Club held its first meeting with 27 members in May 1912 in the home of its first president, Mrs. Thomas Morrow (Elizabeth Post), to set in motion a plan to establish a public library in Brookhaven Hamlet. The library's first home was found in the old school building on Fire Place Neck Road. This building, a gift to the people of Brookhaven Hamlet from James and Louisa Howell Post, was built in 1926. In 1930, the Brookhaven Free Library Association was formed. The Fire Place Literary Club is still in existence today. (Courtesy Bellport-Brookhaven Historical Society.)

The Post-Morrow Foundation, located at 16 Bay Road, is pictured here in a 1929 photograph, taken a few years after the Morrow house was built. The foundation, conceived by Thomas and Elizabeth Post Morrow, was established in 1969 to continue the long tradition of philanthropy to the community that has been the legacy of the Post and Morrow families. Its mission is the preservation of the rural countryside character of the hamlet and the surrounding areas through the acquisition of properties by gift or purchase. (Courtesy Post-Morrow Foundation.)

Eight
HISTORIC HOUSES OF
BROOKHAVEN HAMLET

When the history of a place is valued, its exterior appearance should be preserved in order to maintain a continuity with the past. Our understanding of our heritage is enhanced when tangible reminders of the past remain undisturbed. In addition, much of what was built (or laid out as landscape) is not only appealing—it is irreplaceable.

—Nicholas Langhart
From *Town of Brookhaven Historic District
Advisory Committee Guidelines Handbook* (1990)

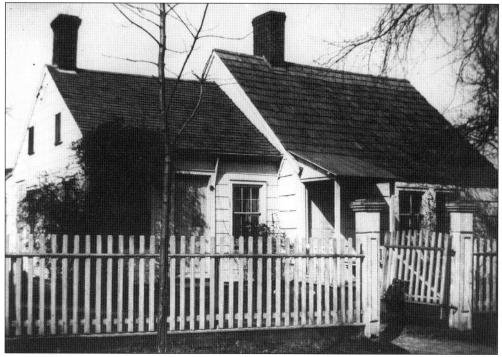

One of the oldest houses extant in Brookhaven Hamlet (more than 260 years old) is this half cape with addition. It once stood on Beaver Dam Road and was moved by the Swezey family to 5 Locust Road. One of its features is the "Christian door," so called because its panels form a cross, which was believed to ward off witchcraft. (Courtesy Brookhaven Free Library.)

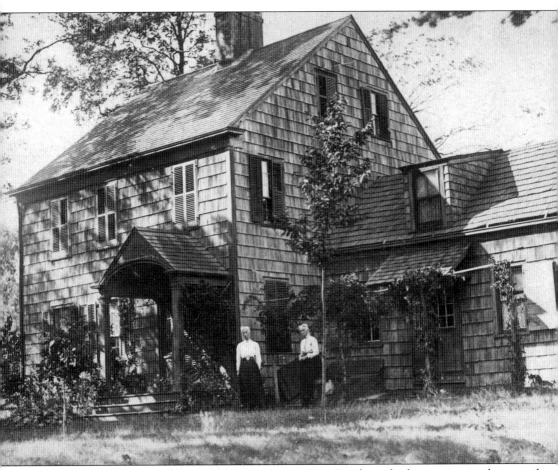

The Senator John Rose Homestead, at 228 Beaver Dam Road, was built sometime in the second decade of the 19th century and was owned by the Rose family for at least 150 years. Members of the Rose family were the first white settlers of Fire Place (Brookhaven Hamlet) and Occumbomock (Bellport) in the 17th century. The house is pictured sometime in the late 19th century with the Rose sisters, Hattie and Cornelia. This house is significant because it looks very much like it did originally and documents how a historically important family lived. (Courtesy Post-Morrow Foundation.)

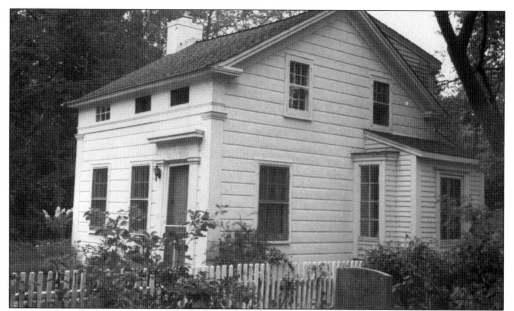

This photograph shows the top part of a former two-and-a-half-story home that was once located on South Country Road. The right-sided front entrance of this Greek Revival house was above a ground-floor living space reached by a set of eight steps, similar to a townhouse. The house was built well before 1873 and was the home of Sam Breckenridge, who came from Brooklyn. It is now a private home at 32 Fireplace Neck Road near the Hulse Cemetery. (Courtesy Robert Duckworth.)

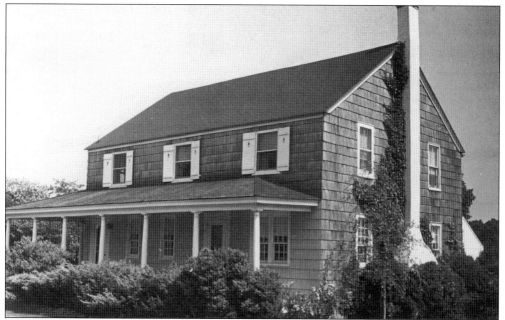

This home, shown in 1958, dates from the beginning of the 19th century and was built for Dea. Daniel Hawkins. It was later called Interlane. It has been substantially altered and moved twice. The house was once owned by artist Frederick Kost, who moved it to its present location at 298 Beaver Dam Road. (Courtesy Prisilla Carleton.)

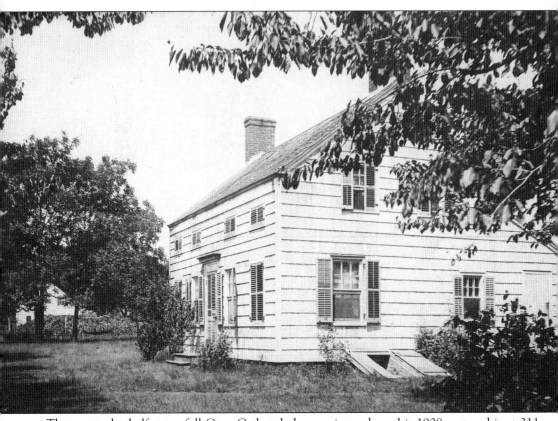

The one-and-a-half-story, full Cape Cod–style house pictured on this 1908 postcard is at 311 Beaver Dam Road and was built by Jesse Rose, whose brothers had fought in the Revolution. It was built in the late 18th century, the homestead of Jesse Rose's farm, with a center chimney, altered and enlarged in 1818 when Selah Hawkins married Rose's daughter. After Selah's death, it was inherited by his son Harmon. Since the full or double cape was the least prevalent variety of capes during the 18th century, it is most likely that before this house was enlarged, it was a half cape. (Courtesy Ellen Williams.)

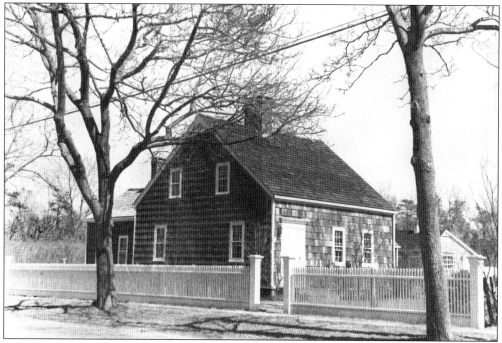

There are two other late-18th or early-19th-century Cape Cod–style houses in Brookhaven Hamlet, and these are of the half cape variety. Both are on South Country Road. The one at No. 408 (above) was the home of Richard Corwin. The other, at No. 319 (below), was the home of Will Rose and was built by his grandfather Mills Clark. Both houses are good examples of the type. (Above courtesy Brookhaven Free Library; below courtesy Bellport-Brookhaven Historical Society.)

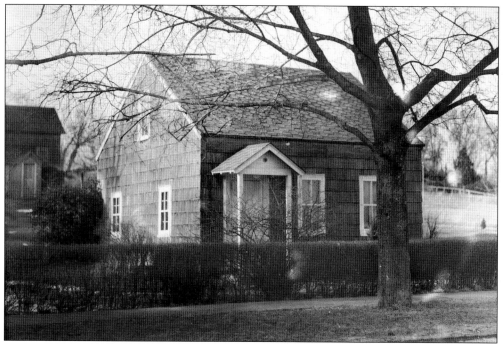

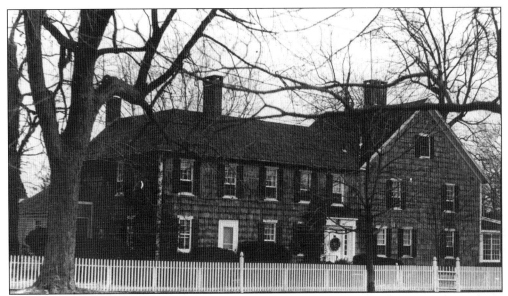

This home was built by Dr. Nathaniel Miller c. 1815 and remained in the Miller family into the second half of the 20th century. When Dr. Miller was postmaster, part of this house served as a post office. This photograph from the 1950s shows the house more or less the way it looks today at 9 Fire Place Neck Road. The oldest part of the house is on the right, and the entrance was on the side, facing south. Nathaniel Miller built the house with a bargelike cellar to keep out water, as the location was near Valentine's Brook. The Miller Farm survived into the mid-20th century with George Miller. (Courtesy Bellport-Brookhaven Historical Society.)

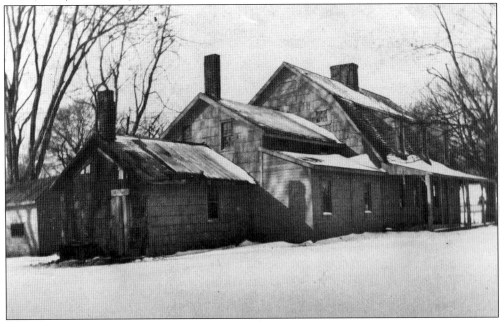

This house was built at the time of the Revolution and was a stagecoach stop and tavern on South Country Road. It was purchased later in the 18th century by the Seaman family. The house was moved away from the road and down to Beaver Dam Creek in 1941. (Courtesy Nancy Ljungquist.)

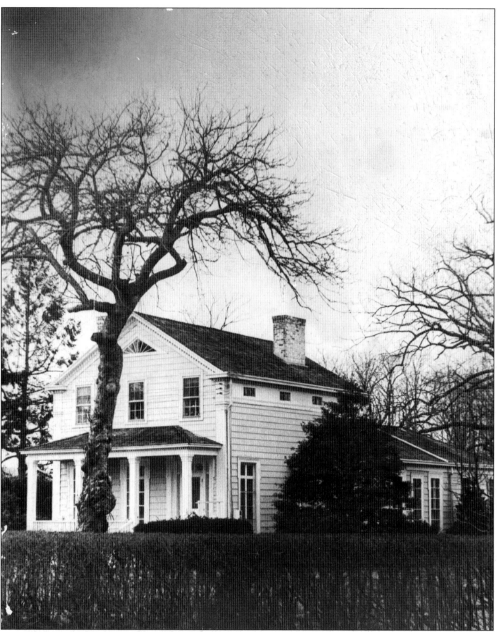

This Greek Revival farmhouse at 325 Beaver Dam Road was built c. 1849 by George H. Burnett, who (after returning from California during the Gold Rush) purchased 107 acres of land here. It has had only three owners: the Burnett family until the 1920s; the Wellington family until 1961; and the current owners, the Rowley family. The house is a superb example of the form: its frieze band is discontinuous across the gable front, which is embellished with an unusual triangular sunburst window. The pilaster ends are bold, with the dentil decoration found in the eaves repeated on the capitals. The front parlor windows go to the floor, and the columned, half-height entry porch is full width. The house has almost always been painted yellow and sits in a perfect rural setting. (Courtesy Bellport-Brookhaven Historical Society.)

BIBLIOGRAPHY

Bellport Bay Yacht Club Seventy-Fifth Anniversary Book. 1983.

Bellport-Brookhaven Historical Society Scrap Book. Museum archives, 1958–1989.

Bigelow, Stephanie S. *Bellport and Brookhaven: A Saga of the Sibling Hamlets at Old Purchase South.* Bellport-Brookhaven Historical Society, 1968.

Bigelow, Paul, and William Hanaway. *Story of Old Inlet.* Bellport, 1952.

Borg, Pamela, and Elizabeth Shreeve. *The Carmans River Story: A Natural and Human History.* Privately printed, 1974.

Borthwick, George. *The Church at the South: A History of the South Haven Church.* Mattituck, New York: Amereon Ltd., 1989.

Danto, Arthur. *Brookhaven Hamlet as Historical District.* Post-Morrow Foundation, 1985.

Edey, Birdsall Otis. *Builders.* The Girl Scouts, 1940.

Finn, Charles M. *Bellport: A Reminiscence.* 1995.

Foley, Mary Mix. *The American House.* New York: Harper and Row, 1980.

Glackens, Ira. *William Glackens and the Ashcan Group: The emergence of Realism in American Art.* New York: Crown Publishers Inc., 1957.

History of Suffolk County. New York: W.W. Munsell and Company, 1882.

Langhart, Nicholas. *Town of Brookhaven Historical District Advisory Committee: Guidelines Handbook.* 1990.

Light, Sally. *House Histories: A Guide to Tracing the Genealogy of Your Home.* Spencertown, New York: Golden Hill Press, 1989.

McAllester, Virginia and Lee. *A Field Guide to American Houses.* New York: Alfred A. Knopf, 1984.

Morse, George Perley. *Early Photographs of the Hamlet of Brookhaven.* Privately printed, 1945–1959.

Myers, Denys Peter, Eva Ingersoll Gatling, and Richard Di Liberto. *The Architecture of Suffolk County.* The Heckscher Museum, 1971.

Shaw, Osborn. A paper written by Osborn Shaw of Bellport for the Fire Place Literary Club and read by him at the Brookhaven Free Library on October 5, 1933.

Shaw, Osborn. *Historical Sketch of Bellport.*

Stevens, William Oliver. *Discovering Long Island.* New York: Dodd, Mead and Company 1939.

Sweeney, George T. *Long Island: The Sunrise Homeland.* New York, 1926.

The Village of Bellport Temporary Zoning Commission. *A Planning Analysis of the Village of Bellport and Draft Environmental Impact Statement.* 1988.

Towne, Charles Hanson. *Loafing Down Long Island.* New York: The Century Company, 1921.

Van Liew, Barbara Ferris. *Long Island Domestic Architecture of the Colonial and Federal Periods.* Setauket, Long Island: The Society for the Preservation of Long Island Antiquities, 1974.

Van Lith, Martin, and Anita Cohen. *A Brief History of Brookhaven Hamlet.* Post-Morrow Foundation, 1985.

Williams, Henry Lionel, and K. Ottalie. *Old American Houses 1700–1850: How to Restore, Remodel and Reproduce Them.* New York: Bonanza Books, 1957.